POSTCARD HISTORY SERIES

Santa Monica
IN VINTAGE POSTCARDS

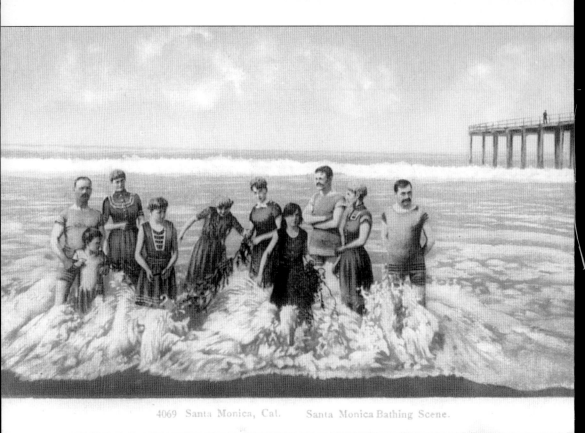

SANTA MONICA, CAL. SANTA MONICA BATHING SCENE. (P/P: Paul C. Koeber, New York & Kirchheim, Germany. No. 4069.)

POSTCARD HISTORY SERIES

Santa Monica
IN VINTAGE POSTCARDS

Marlin L. Heckman

Copyright © 2002 by Marlin L. Heckman
ISBN 0-7385-2055-1

Published by Arcadia Publishing,
an imprint of Tempus Publishing, Inc.
3047 N. Lincoln Ave., Suite 410
Chicago, IL 60613

Printed in Great Britain.

Library of Congress Catalog Card Number: Applied For.

For all general information contact Arcadia Publishing at:
Telephone 843-853-2070
Fax 843-853-0044
E-Mail sales@arcadiapublishing.com

For customer service and orders:
Toll-Free 1-888-313-2665

Visit us on the internet at http://www.arcadiapublishing.com

All but one of the images in this book are from the author's personal collection.

DEDICATION

This volume is dedicated to Lee Brown of Adventure in Postcards, Sunland, CA, in appreciation for her friendship and her willingness to share her expertise as a postcard dealer.

CONTENTS

Introduction		7
1.	Where the Mountains Meet the Sea	9
2.	At the Pacific's Edge	31
3.	Santa Monica: Buildings and Structures	53
4.	Santa Monica: Sights	87
5.	Ocean Park and Venice	105
Index of Publishers/Photographers		128

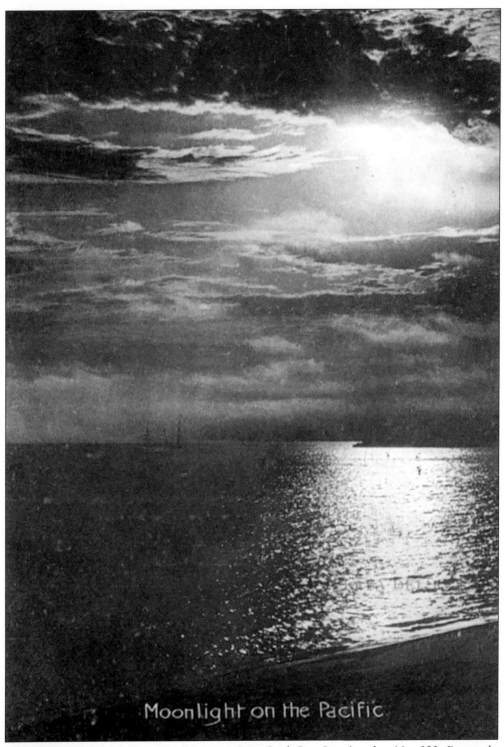

MOONLIGHT ON THE PACIFIC. (Newman Post Card Co., Los Angeles. No. 323, Postmark: January 1908.)

INTRODUCTION

As a Southern California seaside resort, the town of Santa Monica has always been favored by good weather. In 1899, an ad writer made special note of the weather: "At Santa Monica the climate is tempered in Summer by ocean breezes and in winter by sunshine. It is, therefore, June the year round." (Advertisement in *The Land of Sunshine, a Magazine of California and the Southwest*, September 1899.)

The City of Santa Monica, California, was founded by state senator John P. Jones and Col. R.S. Baker and they recorded a map of Santa Monica in the Los Angeles County Recorder's office on July 10, 1975. Easy access to the new city was planned by constructing the Los Angeles and Independence railroad between Santa Monica and Los Angeles 14-miles inland. The dream was that Santa Monica was to be the beach resort and the seaport for the City of Los Angeles.

In 1907, historical society president J.M. Guinn wrote of the town: "On the 16th day of July, 1875, a great sale of lots was held. An excursion steamer came down from San Francisco loaded with lot buyers and the people of Los Angeles and neighboring towns rallied in great numbers to the site of the prospective maritime metropolis of the south. Tom Fitch, the silver-tongued orator of the Pacific slope, inaugurated the sale by one of his most brilliant orations. He drew a fascinating picture of the 'Zenith City by the Sunset Sea,' as he named it, when at a day not far distant the white sails of commerce should fill its harbor, the products of the Occident and the Orient load its wharves and the smoke from its factory chimneys darken the heavens. Lots on the barren mesa sold at prices ranging from $125 to $500. The sale was a great success."

In 1887, the Southern California land boom touched Santa Monica and, as in many other cities at the time, another great land auction was held. According to Harris Newmark, Ben Word advertised in June 1887: "HO, FOR THE BEACH. Tomorrow, Tomorrow. Grand Auction Sale at Santa Monica. 350 acres. One of the grandest panoramic views the human eye ever rested upon…" (Harris Newmark, *Sixty Years in Southern California, 1853–1913*. Los Angeles: Zeitlin & Ver Brugge, 1970, p. 580.) That same year the Arcadia Hotel was built on the edge of the sand. A contemporary advertisement described the hotel: "The Arcadia Hotel has 150 pleasant rooms, facing the ocean or a beautiful lawn, an airy ballroom, first class orchestra, excellent cuisine and courteous attendants. Surf and Hot Sea Water baths, a positive cure for nervous and rheumatic disorders." (*Land of Sunshine, a Magazine of California and the Southwest*, November 1897.) The hotel is said to have been named for the wife of Santa Monica's co-founder, Col. R.S. Baker.

In 1888 Senator Jones and Mrs. Baker presented a deed of 300 acres for the National Home for Disabled Volunteer Soldiers. Thus began the nearby town of Sawtelle. In 1891-92 the Long Wharf, Port of Los Angeles, north of Santa Monica was built.

From early years photography played an important part in telling the world about Santa Monica. Harris Newmark quotes an unidentified early newspaper account about the 1870s photographer, Henry T. Paye:"To make photographs of *moving* life, such as Mr. Paye's bathing scenes at Santa Monica next Sunday, IT IS ABSOLUTELY NECESSARY THAT EVERYBODY SHOULD KEEP PERFECTLY STILL during the few seconds the plate is being exposed, for the least move might completely spoil an otherwise beautiful effect. Santa Monica with its bathers in nice costume, sporting in the surf, with here and there an artistically-posed group basking in the sunshine, ought to make a beautiful picture." (Harris Newmark, *Sixty Years in Southern California, 1853–1913.* Los Angeles: Zeitlin & Ver Brugge, 1970, p. 466.)

Phrases used to describe early Santa Monica included: "Where Summer Spends the Year," "The Pearl of the Pacific," "The Gem by the Sea," "Mountain Guarded," "Ocean Washed," "Sun Kissed." By 1896 the Pacific Electric Railway began to bring thousands of tourists to the beach and brought about a new spurt of growth for the beach cities of Southern California.

Developments in and around Santa Monica in the late-19th and early-20th century continued to foster the resort atmosphere of the area. The Long Wharf into the Pacific, built in 1893, was intended to make Santa Monica into the Port of Los Angeles. That name and function was later captured by San Pedro harbor to the South. The Santa Fe Railroad had its Pacific terminus in what became the next door city of Ocean Park. Santa Monica Pier was dedicated September 9, 1909, with a crowd of 5,000 present. Salt water rusted the steel in the pilings and it was replaced in 1920 with a wood pier. Pleasure Piers at Ocean Park and Venice, with their casinos, dance halls, etc. also brought thousands of tourists to the area. Sea storm and fire were hazards for several piers in the area over the years.

Today residents and visitors to Santa Monica continue to enjoy the ocean front strip of land along the bluff, which was dedicated in 1892 as a public park, with its beautiful views of the Pacific, particularly at sunset. Santa Monica is still "Where the Mountains Meet the Sea" and the "Gem of the Sea."

The postcards in this volume help to remind us of days gone by and some buildings and places that are no more.

One
WHERE THE MOUNTAINS MEET THE SEA

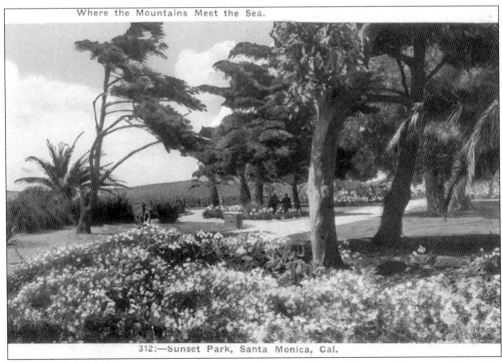

WHERE THE MOUNTAINS MEET THE SEA, SUNSET PARK, SANTA MONICA, CAL. (M. Kashower Co., Los Angeles. No. 312, Postmark: October 1928.)

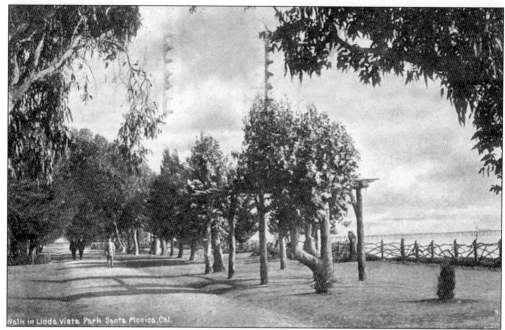

WALK IN LINDA VISTA PARK, SANTA MONICA, CAL. (Edward H. Mitchell, San Francisco. No. 312, Postmark: August 1920.)

WALK IN LINDA VISTA PARK, SANTA MONICA, CALIFORNIA. (Edward H. Mitchell, San Francisco. No. 2512.)

A WALK IN SANTA MONICA, CAL. (Detroit Photographic Co. No. 7870.)

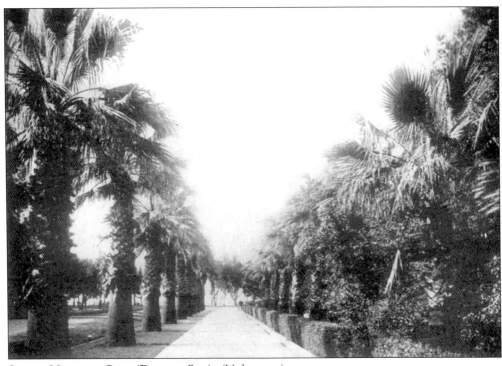
SANTA MONICA, CAL. (BY THE SEA). (Unknown.)

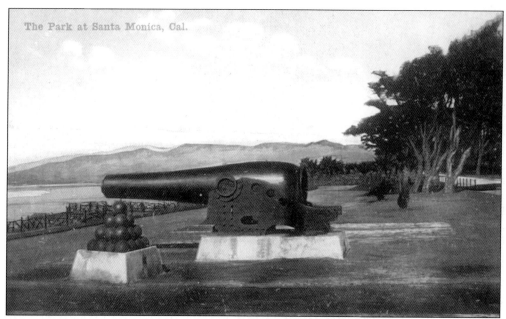

THE PARK AT SANTA MONICA, CAL. (Newman Post Card Co., Los Angeles. No. F4.)

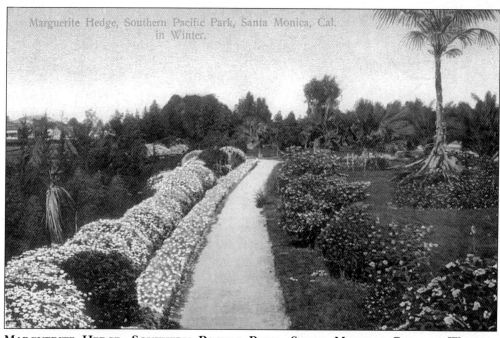

MARGUERITE HEDGE, SOUTHERN PACIFIC PARK, SANTA MONICA, CAL., IN WINTER. (George O. Restall, Los Angeles. No. S.M.2, Made in Germany.)

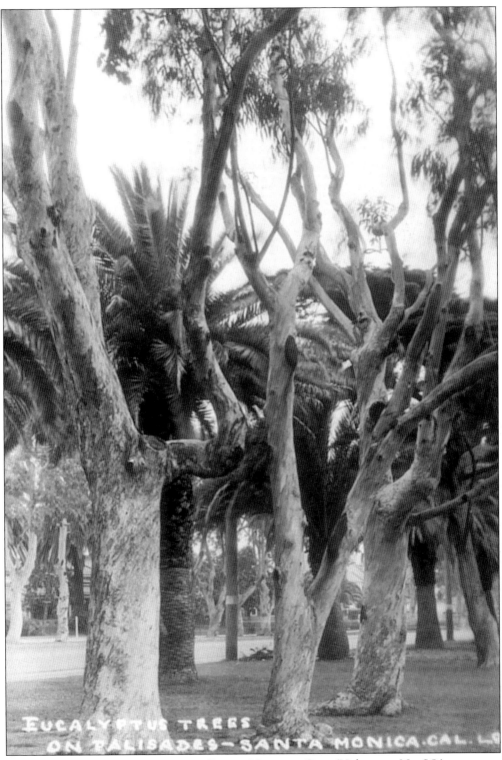
EUCALYPTUS TREES ON PALISADES, SANTA MONICA, CAL. (Unknown, No. L8.)

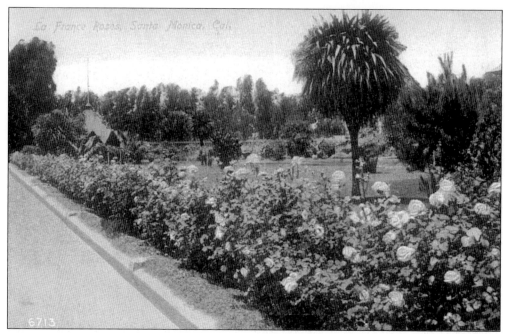

LA FRANCE ROSES, SANTA MONICA, CAL. (Paul C. Koeber, New York and London. No. 6713.)

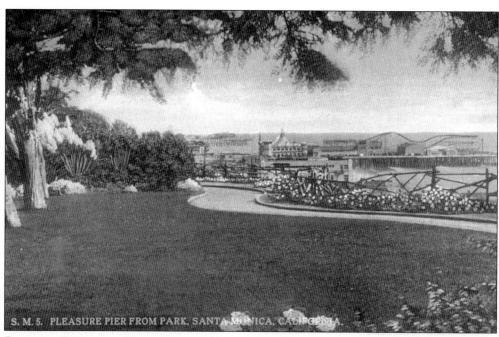

PLEASURE PIER FROM PARK, SANTA MONICA, CALIFORNIA. (Western Publishing & Novelty, Los Angeles. No. S.M.5.)

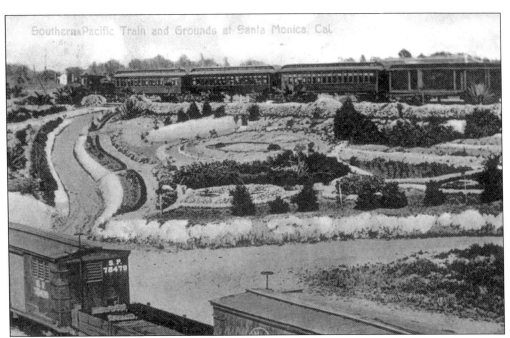

SOUTHERN PACIFIC TRAIN AND GROUNDS AT SANTA MONICA, CAL. (Newman Post Card Co., Los Angeles. No. 5382. Made in Germany. Postmark: September 1907.)

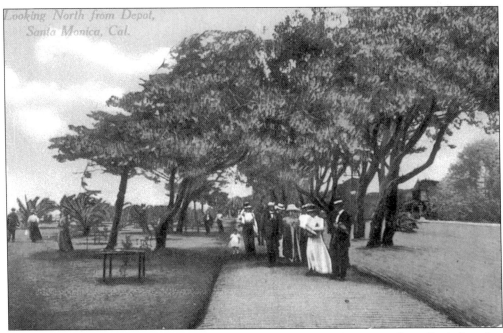

LOOKING NORTH FROM DEPOT, SANTA MONICA, CAL. (Newman Post Card Co., Los Angeles. No. F15.)

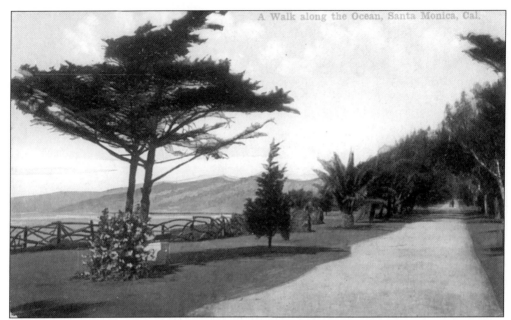

A WALK ALONG THE OCEAN, SANTA MONICA, CAL. (Newman Post Card Co., Los Angeles. No. F12.)

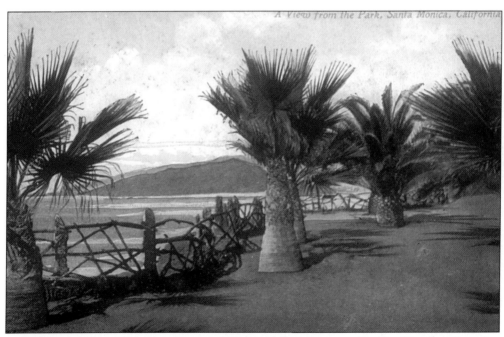

A VIEW FROM THE PARK, SANTA MONICA, CALIFORNIA. (Pacific Novelty Co., San Francisco. No. F155.)

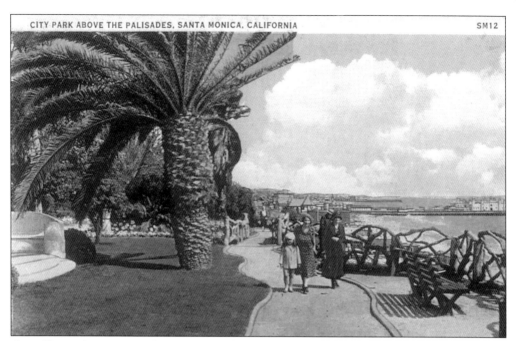

CITY PARK ABOVE THE PALISADES, SANTA MONICA, CALIFORNIA. The Pacific—Bathing Beaches—Beach Clubs, and City Park of Palms above the Palisades at Santa Monica. (News Stand Distributors, Los Angeles. No. S.M.12.)

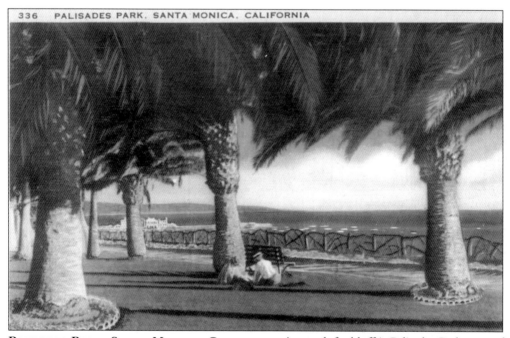

PALISADES PARK, SANTA MONICA, CALIFORNIA. Atop a lofty bluff is Palisades Park, one of the most beautiful on the Pacific Coast, where amid tropical palms and gay flowers, one may rest and view the grandeur of the blue Pacific. (Longshaw Card Co., Los Angeles. No. 336.)

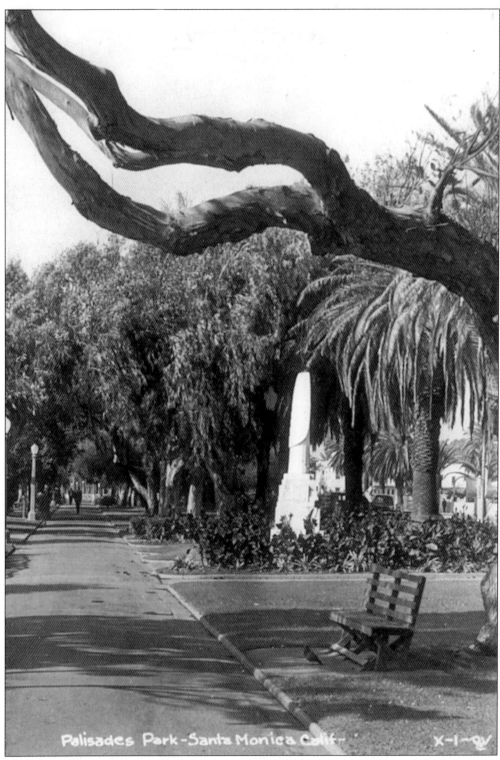
PALISADES PARK, SANTA MONICA, CALIF. (Unknown.)

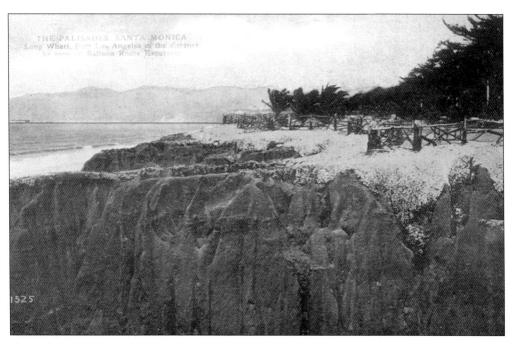

THE PALISADES, SANTA MONICA. PORT LOS ANGELES IN THE DISTANCE. AS SEEN ON THE BALLOON ROUTE EXCURSION. The Scenic Trolley Trip was 100 miles for 100¢—a whole day for one dollar. (Benham Co., Los Angeles. No. 1525.)

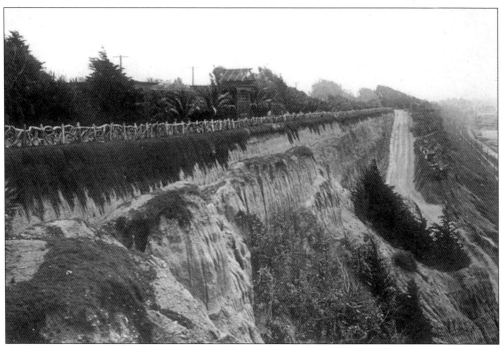

[CLIFF AND PARK IN SANTA MONICA.] (Unknown.)

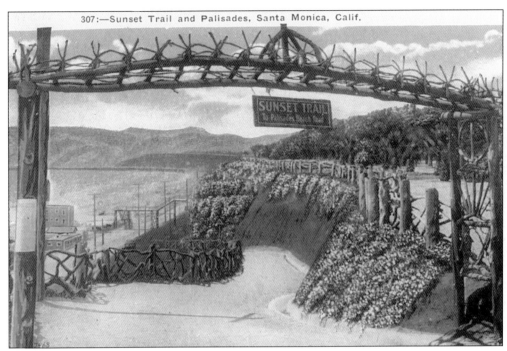

SUNSET TRAIL AND PALISADES, SANTA MONICA, CALIF. (M. Kashower Co., Los Angeles. No. 307.)

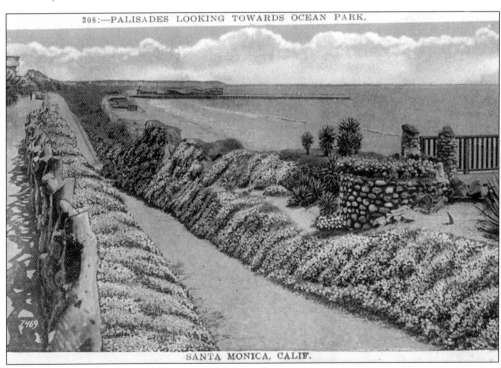

PALISADES LOOKING TOWARD OCEAN PARK, SANTA MONICA, CALIF. (M. Kashower Co., Los Angeles. No. 308.)

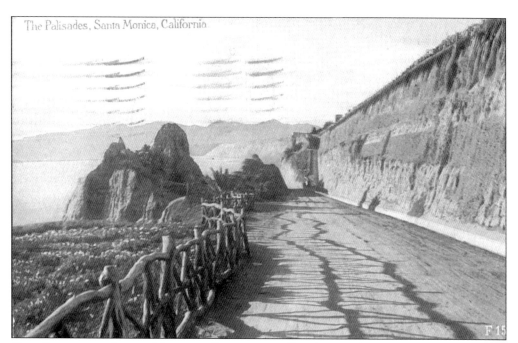

THE PALISADES, SANTA MONICA, CALIFORNIA. (Pacific Novelty Co., San Francisco. No. F156. Postmark: August 1926.)

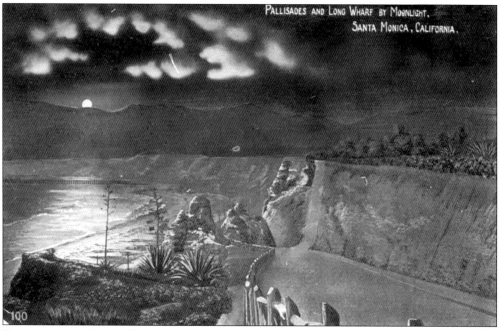

PALISADES AND LONG WHARF BY MOONLIGHT, SANTA MONICA, CALIFORNIA. (Unknown. No. 100.)

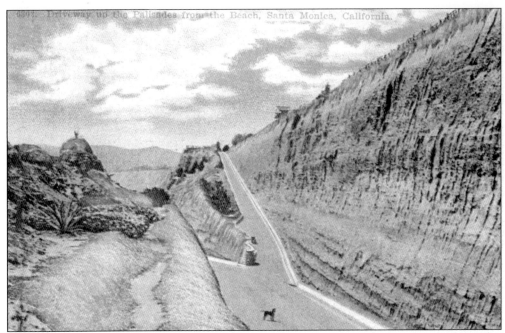

Driveway up the Palisades from the Beach, Santa Monica, California.
(Cardinell-Vincent Co., San Francisco, Los Angeles. No. 6802.)

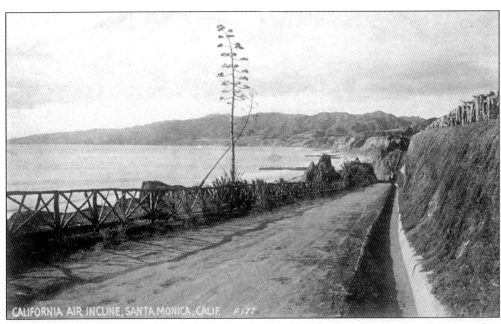

California Air Incline, Santa Monica, Calif. (Pacific Novelty Co., San Francisco, Los Angeles. No. F177.)

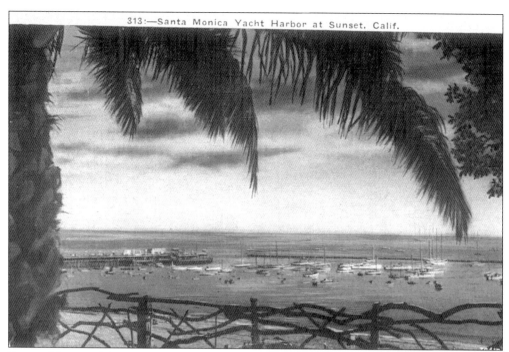

SANTA MONICA YACHT HARBOR AT SUNSET, CALIF. (M. Kashower Co., Los Angeles. No. 313. Postmark: August 1937.)

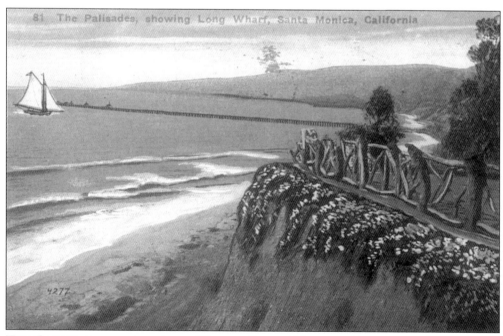

THE PALISADES, SHOWING LONG WHARF, SANTA MONICA, CALIFORNIA. (M. Kashower Co., Los Angeles. No. 81. Postmark: September 1915.)

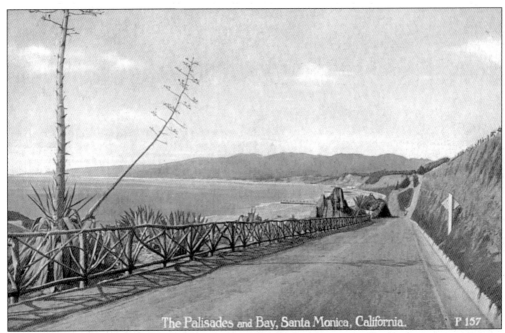

THE PALISADES AND BAY, SANTA MONICA, CALIFORNIA. (Pacific Novelty Co., San Francisco & Los Angeles. No. P157.)

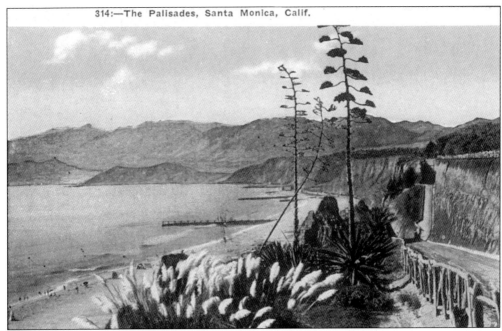

THE PALISADES, SANTA MONICA, CALIF. (M. Kashower Co., Los Angeles. No. 314.)

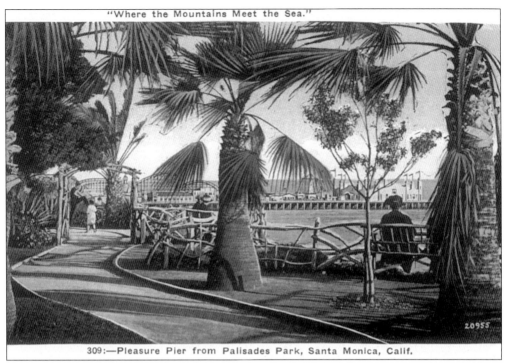

"WHERE THE MOUNTAINS MEET THE SEA." PLEASURE PIER FROM PALISADES PARK, SANTA MONICA, CALIF. (M. Kashower Co., Los Angeles. No. 309.)

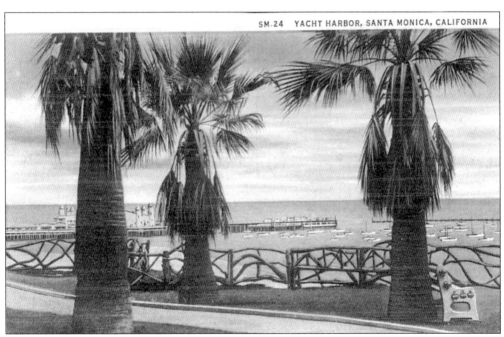

YACHT HARBOR, SANTA MONICA, CALIFORNIA. (Western Publishing Co., Los Angeles. No. S.M.24. Postmark: April 1947.)

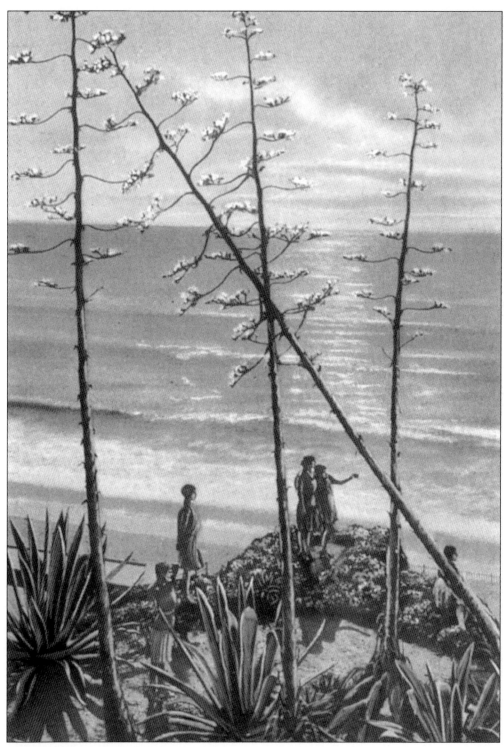

SUNSET POINT, PALISADES, SANTA MONICA, CALIFORNIA. (Western Publishing & Novelty Co., Los Angeles. No. S.M.42.)

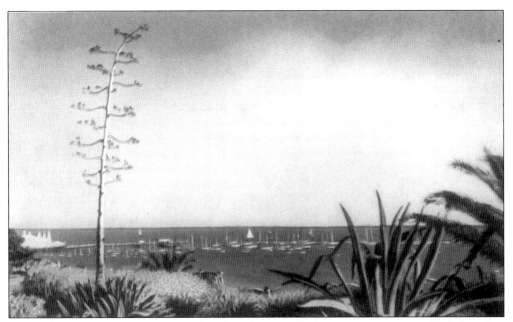

OVERLOOKING YACHT HARBOR, SANTA MONICA, CALIFORNIA. (Longshaw Card Co., Los Angeles. No. 337.)

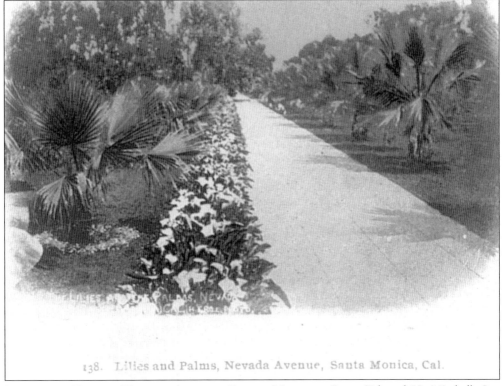

LILIES AND PALMS, NEVADA AVENUE, SANTA MONICA, CAL. (Edward H. Mitchell, San Francisco. No. 138.)

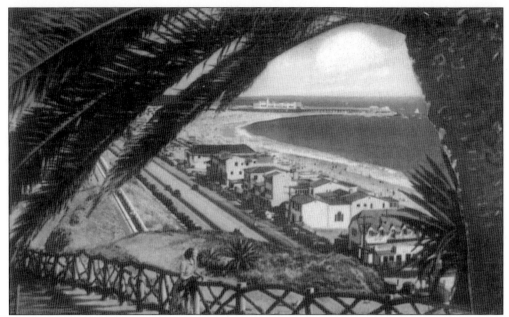

OVERLOOKING BEACH HOMES AND BEACH, SANTA MONICA, CALIFORNIA. From the majestic Palisades of Santa Monica, one may view the movie stars' homes on the beach, as well as the interesting marine activity of the municipal harbor. (Longshaw Card Co., Los Angeles. No. 335.)

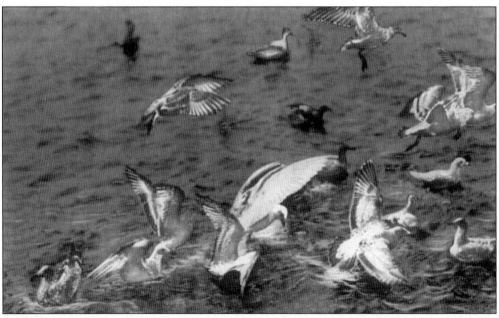

SEAGULLS OF THE CALIFORNIA COAST AT SANTA MONICA. The flashing white wings of the seagulls wheeling over the blue sea is a sight long associated with the Pacific coast beaches. (Longshaw Card Co., Los Angeles. No. 340.)

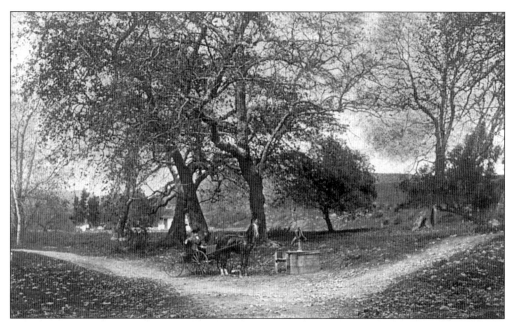

SCENE IN THE PICTURESQUE SANTA MONICA CANYON. 'A rendezvous for picnic lovers, about 2 miles from Santa Monica, Cal.' (M. Rieder, Los Angeles. No. 4633. Made in Germany.)

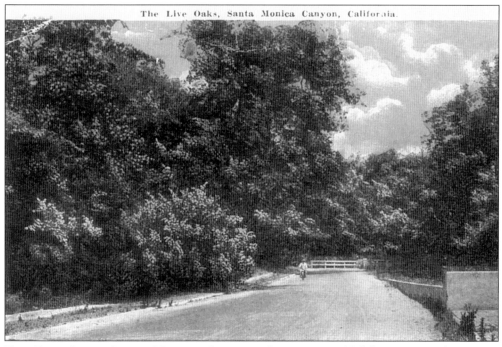

THE LIVE OAKS, SANTA MONICA CANYON, CALIFORNIA. (California Postcard Co., Los Angeles. Postmark: September 1937.)

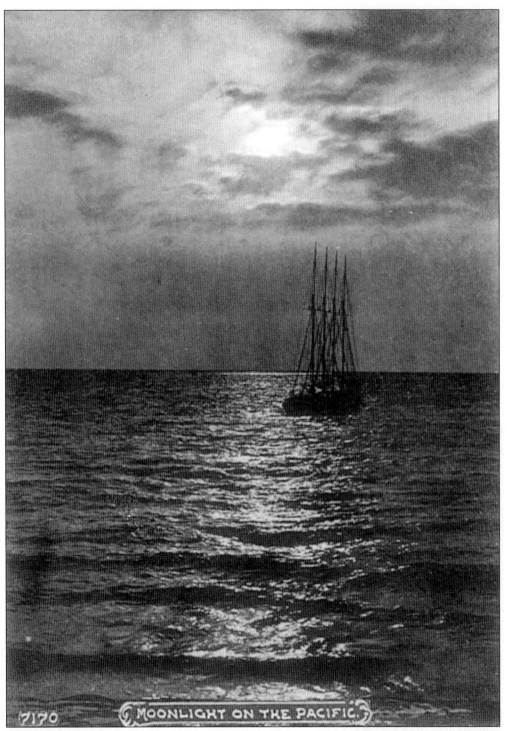
MOONLIGHT ON THE PACIFIC, SANTA MONICA, CAL. (M. Rieder, Los Angeles. No. 7170.)

Two
AT THE PACIFIC'S EDGE

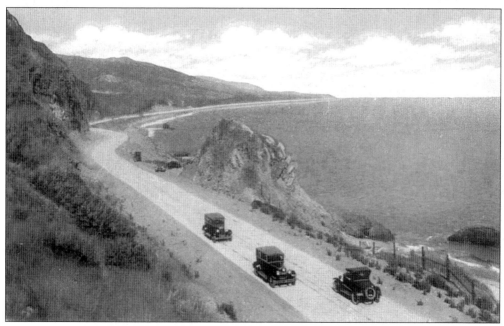

COAST HIGHWAY, NEAR LOS FLORES CANYON, NORTH OF SANTA MONICA, CALIFORNIA.
(Western Publishing & Novelty Co., Los Angeles. No. S.M.21.)

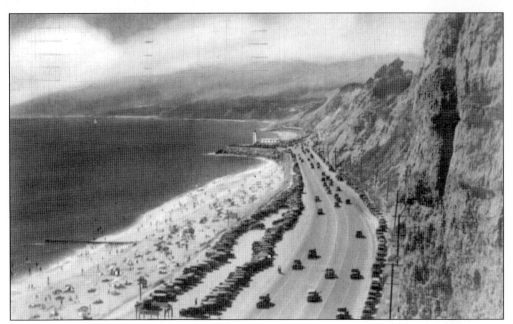

Lighthouse on Will Rogers Estate, Santa Monica, California. (Longshaw Card Co., Los Angeles. No. 333. Postmark: November 1943.)

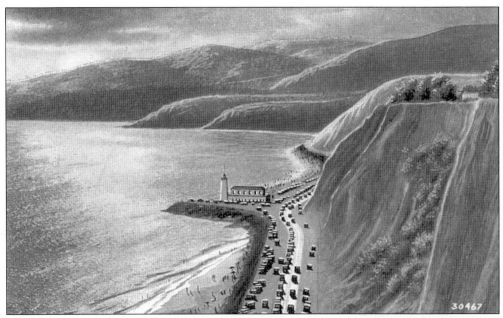

Sunset along Roosevelt Highway, above Santa Monica, Calif. (M. Kashower Co., Los Angeles. No. 335.)

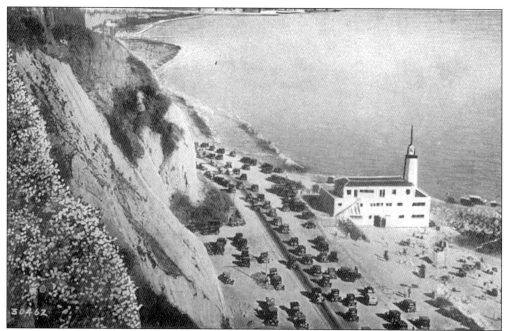

LIGHTHOUSE, PACIFIC PALISADES BEACH, SANTA MONICA, CALIF. (M. Kashower Co., Los Angeles. No. 333.)

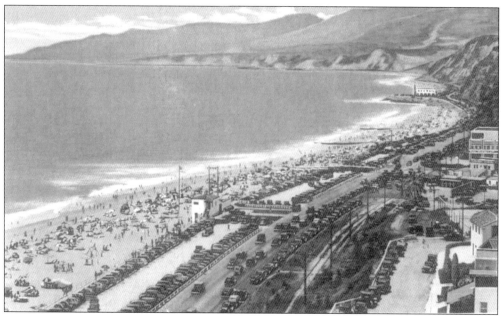

LOS ANGELES COUNTY BEACH, SANTA MONICA, CALIFORNIA. (Western Publishing & Novelty Co., Los Angeles. No. S.M.33.)

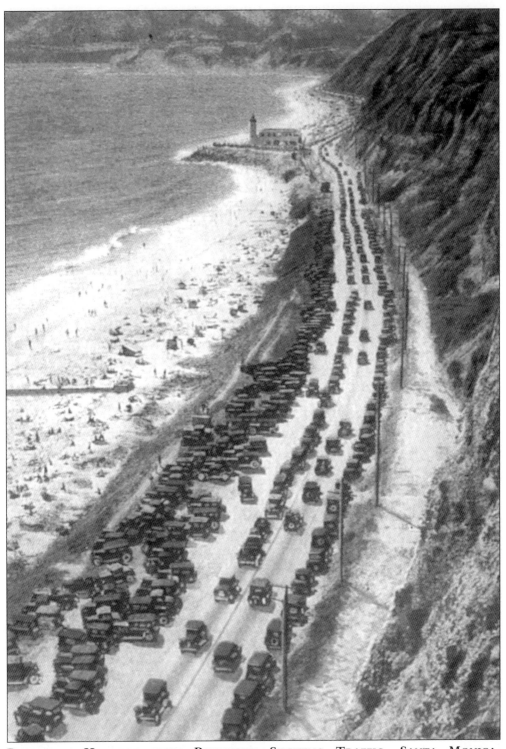

ROOSEVELT HIGHWAY FROM PALISADES, SHOWING TRAFFIC, SANTA MONICA, CALIFORNIA. (California Greeting and Post Card Co., Los Angeles. No. 17866.)

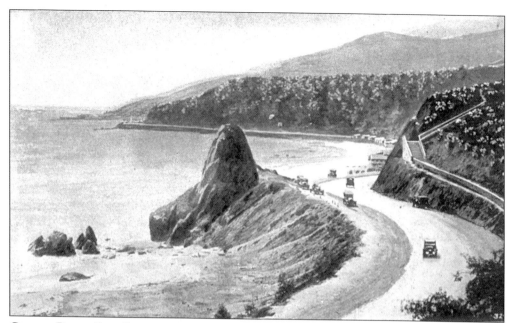

CASTLE ROCK "ON ROOSEVELT HIGHWAY," SANTA MONICA, CALIF. (M. Kashower Co., Los Angeles. No. 304.)

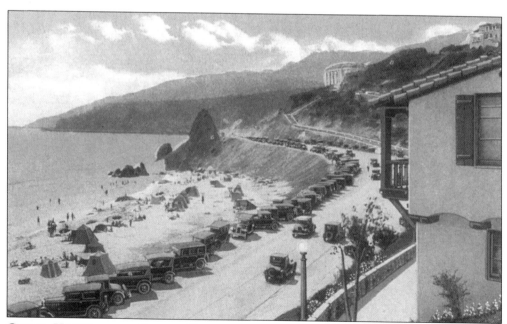

COAST HIGHWAY AT CASTLE ROCK, NEAR SANTA MONICA, CALIFORNIA. (Western Publishing & Novelty Co., Los Angeles. No. S.M.19.)

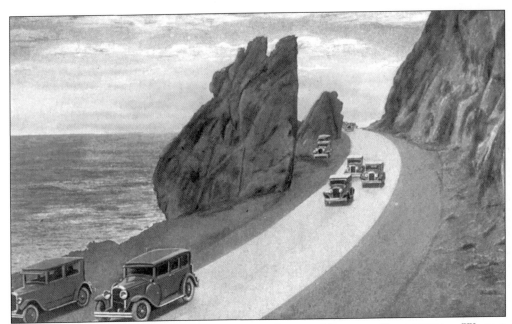

ON THE ROOSEVELT HIGHWAY NORTH OF SANTA MONICA, CALIFORNIA. (Western Publishing & Novelty Co., Los Angeles. No. S.M.26.)

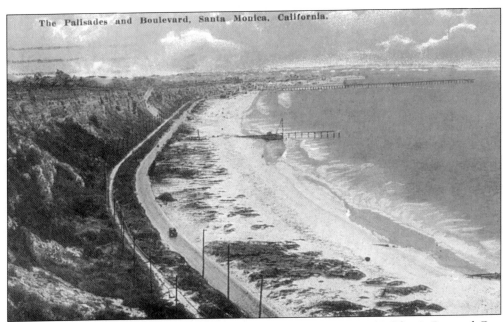

THE PALISADES AND BOULEVARD, SANTA MONICA, CALIFORNIA. (California Postcard Co., Los Angeles. Postmark: January 1923.)

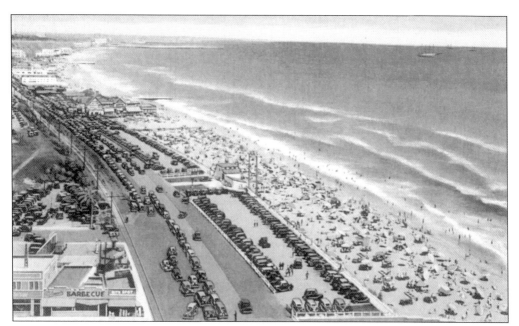

BEACH, LOS ANGELES COUNTY PLAYGROUND, SANTA MONICA, CALIFORNIA. (Western Publishing & Novelty Co., Los Angeles. No. S.M.34.)

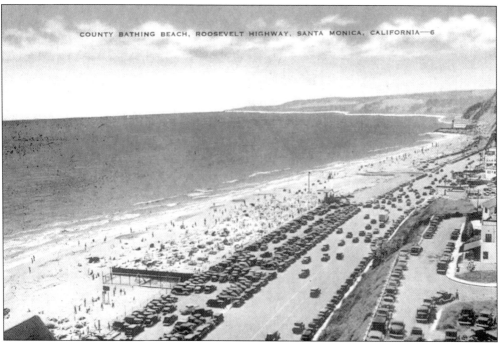

COUNTY BATHING BEACH, ROOSEVELT HIGHWAY, SANTA MONICA, CALIFORNIA. (Bay News Co., Ocean Park, Calif. No. 6.)

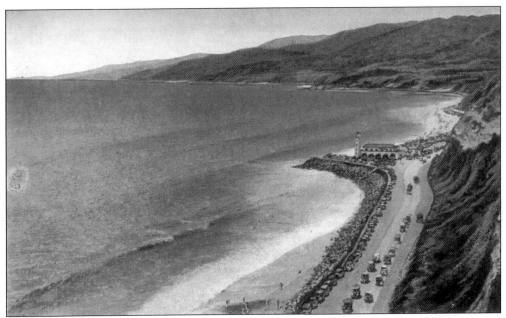

COAST LINE ALONG ROOSEVELT HIGHWAY, ABOVE SANTA MONICA, CALIFORNIA. (Tichnor Art Co., Los Angeles. No. T255.)

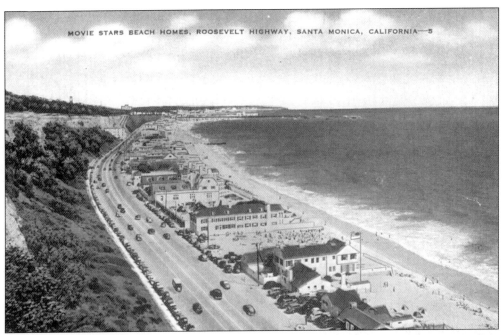

MOVIE STARS BEACH HOMES, ROOSEVELT HIGHWAY, SANTA MONICA, CALIFORNIA. (Bay News Co., Ocean Park, Calif. No. 5.)

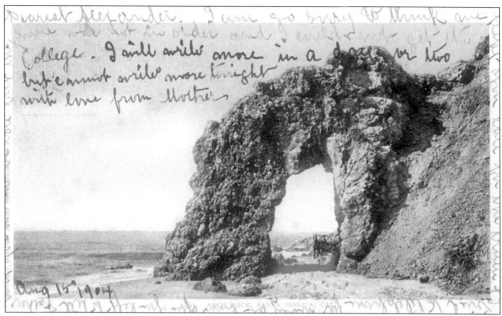

ARCH ROCK, SANTA MONICA, CAL. (Detroit Photographic Co. No. 5895. Copyright 1902. Postmark: August 1904.)

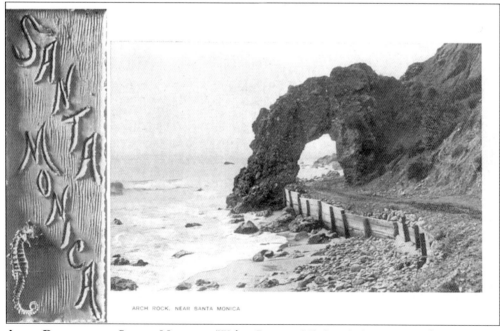

ARCH ROCK, NEAR SANTA MONICA. (Walter Reeves, Mission Artist, Los Angeles.)

COAST SCENE NEAR SANTA MONICA, CALIFORNIA. (Pacific Novelty Co., Los Angeles. No. F158.)

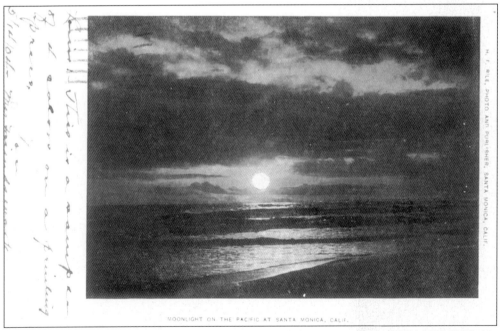

MOONLIGHT ON THE PACIFIC AT SANTA MONICA, CALIF. Note on card: 5/14/04 "This is a sample of four colors on a printing press. My friend's work." (H.F. Rile, Santa Monica, Calif. Postmark: May 1904.)

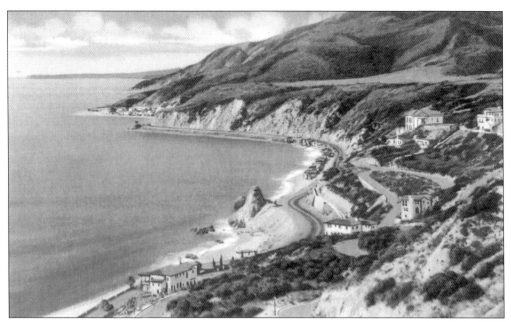

A GENERAL VIEW OF THE COAST HIGHWAY FROM PALISADES ABOVE CASTLE ROCK.
(Western Publishing & Novelty Co., Los Angeles. No. S.M.39.)

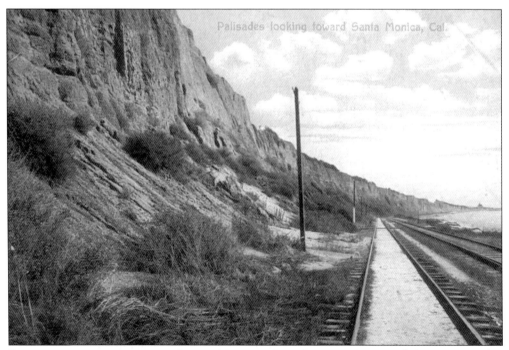

PALISADES LOOKING TOWARD SANTA MONICA CAL. (Newman Post Card Co., Los Angeles. No. 6173. Made in Germany. Postmark: September 1907.)

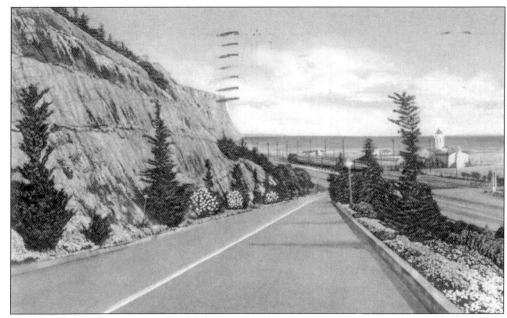

A CALIFORNIA HIGHWAY, ALONG THE PALISADES ON U.S. HIGHWAY 101. (Western Publishing & Novelty Co., Los Angeles. No. R25. Postmark: February 1939.)

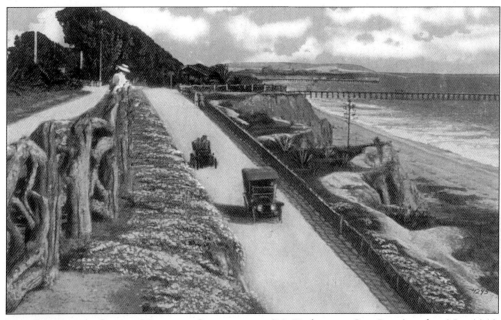

THE PALISADES, SANTA MONICA, CALIFORNIA. (M. Kashower, Co., Los Angeles. No. 114.)

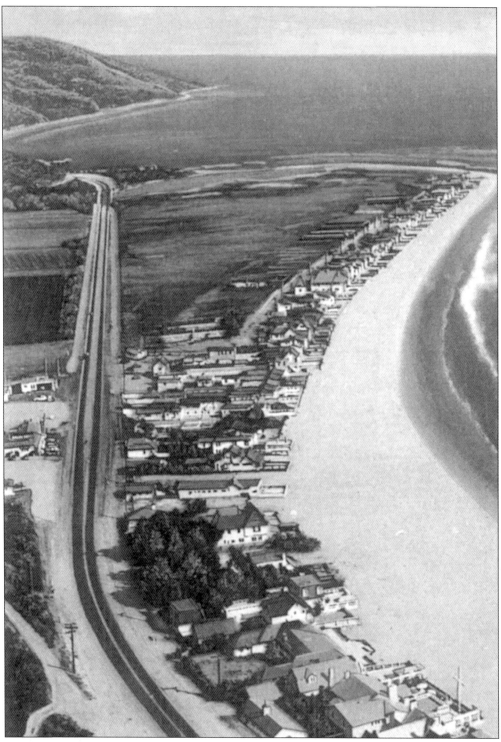

MALIBU MOVIE COLONY, ROOSEVELT HIGHWAY NEAR SANTA MONICA, CALIFORNIA.
(Western Publishing & Novelty Co., Los Angeles. No. S.M.15.)

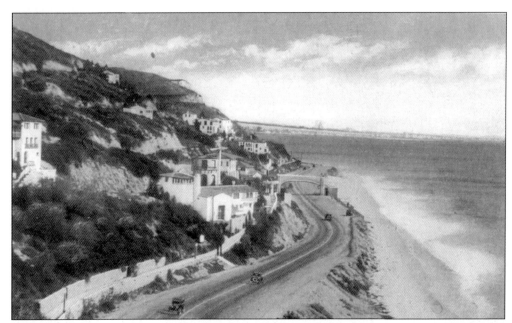

LOOKING SOUTH ON COAST HIGHWAY, SANTA MONICA, CALIFORNIA IN THE DISTANCE.
(Western Publishing & Novelty Co., Los Angeles. No. S.M.40. Postmark: October 1934.)

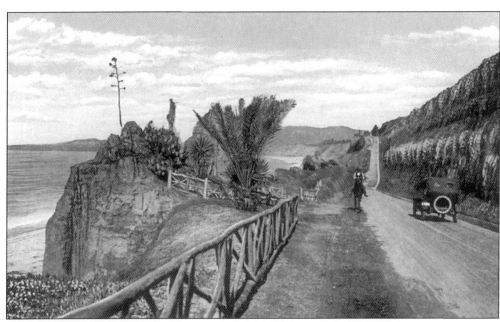

ALONG THE PALISADES, SANTA MONICA, CALIFORNIA. (Western Publishing & Novelty Co., Los Angeles. No. S.M.8.)

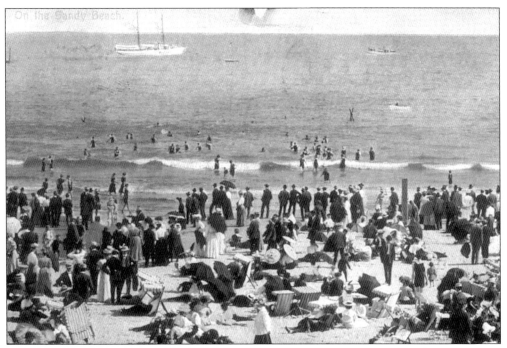

ON THE SANDY BEACH. (Newman Post Card Co., Los Angeles. No. D12. Made in Germany. Postmark: September 1909.)

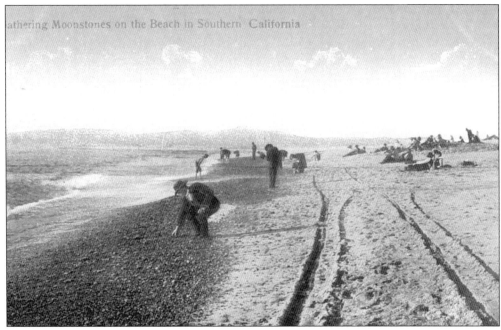

GATHERING MOONSTONES ON THE BEACH IN SOUTHERN CALIFORNIA. (M. Rieder, Los Angeles. No. D17.)

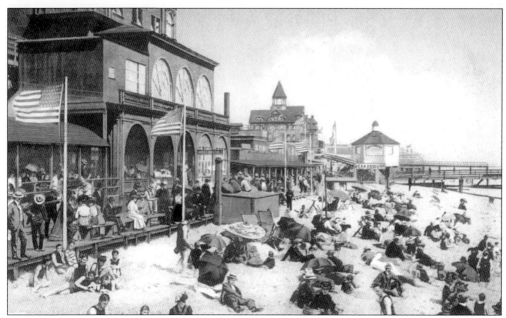

Santa Monica, Cal. North Beach and Bath House. (Paul C. Koeber Co., New York & Kirchheim [Germany]. No. 4066.)

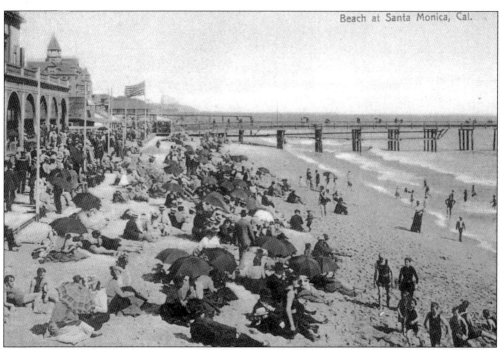

Beach at Santa Monica, Cal. (M. Rieder, Los Angeles. No. 2014. Printed in Germany.)

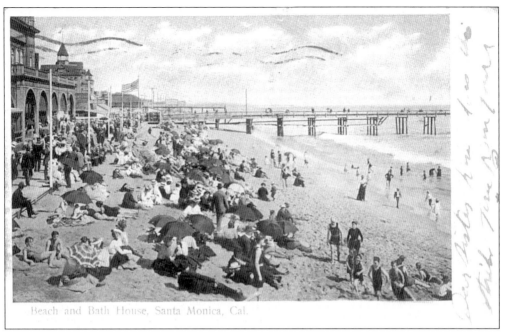

BEACH AND BATH HOUSE, SANTA MONICA, CAL. (M. Rieder, Los Angeles & Leipzig. No. 3240. Postmark: March 1907.)

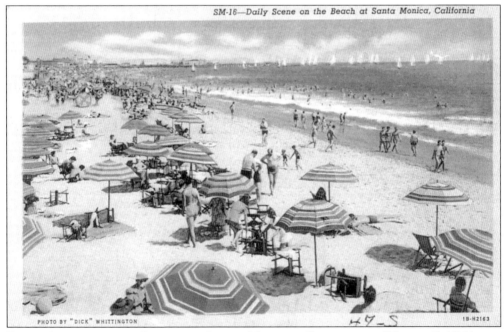

DAILY SCENE ON THE BEACH AT SANTA MONICA, CALIFORNIA. (Western Publishing & Novelty Co., Los Angeles. No. S.M.16. Postmark: March 1947.)

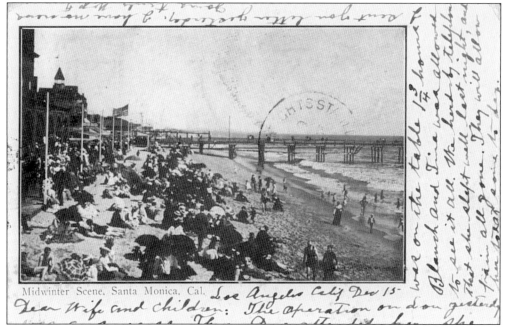

MIDWINTER SCENE, SANTA MONICA, CAL. (J.T. Sheward, Pub., Los Angeles. Postmark: December 1905.)

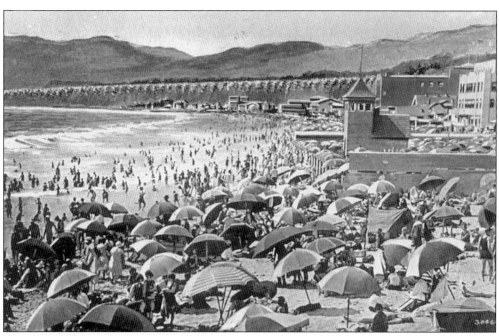

SANTA MONICA BEACH ABOVE MUNICIPAL PIER, SANTA MONICA, CALIF. (M. Kashower Co., Los Angeles. No. 341. Postmark: July 1936.)

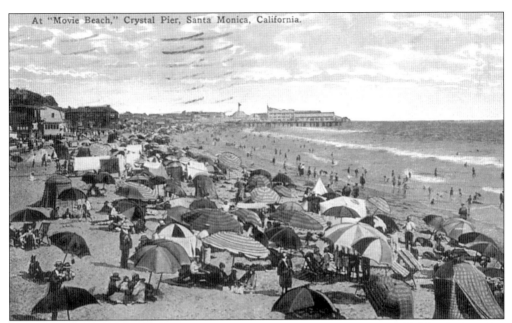

AT "MOVIE BEACH," CRYSTAL PIER, SANTA MONICA, CALIFORNIA. (California Greeting & Post Card Co., Los Angeles. No. 25129. Postmark: August 1926.)

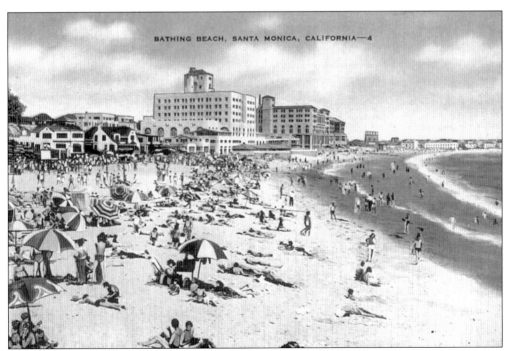

BATHING BEACH, SANTA MONICA, CALIFORNIA. (Bay News Co., Los Angeles. No. 4.)

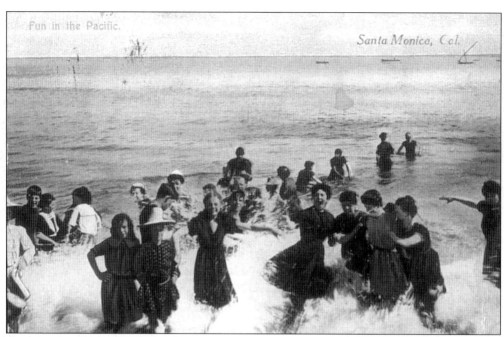

FUN IN THE PACIFIC, SANTA MONICA, CAL. (Newman Post Card Co., Los Angeles. No. P4. Postmark: October 1909.)

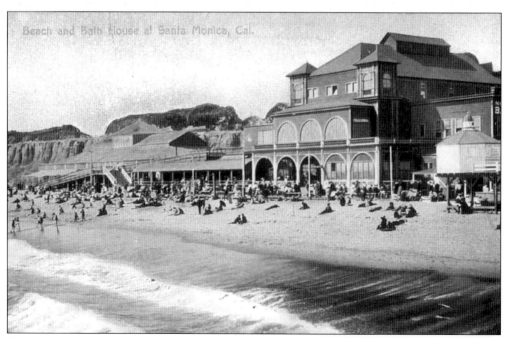

BEACH AND BATH HOUSE AT SANTA MONICA, CAL. (Newman Post Card Co., Los Angeles. No. 5172.)

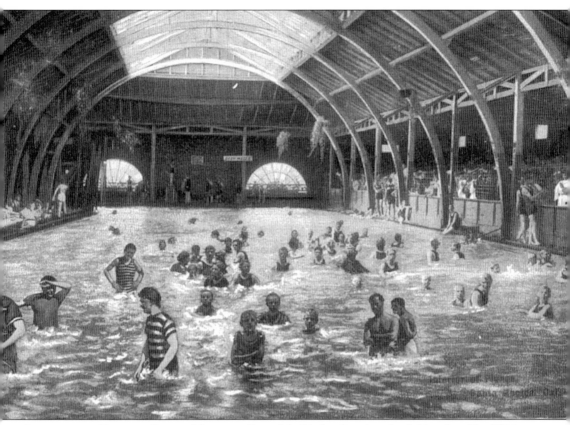

INTERIOR OF PLUNGE, SANTA MONICA, CAL. (M. Rieder, Los Angeles & Dresden. No. 9056. Postmark: March 1908.)

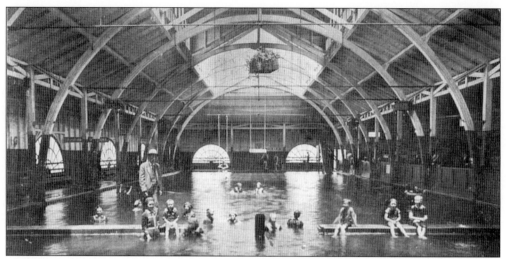

INTERIOR OF PLUNGE, SANTA MONICA BATH HOUSE. (Walter Reeves, Mission Artist, Los Angeles.)

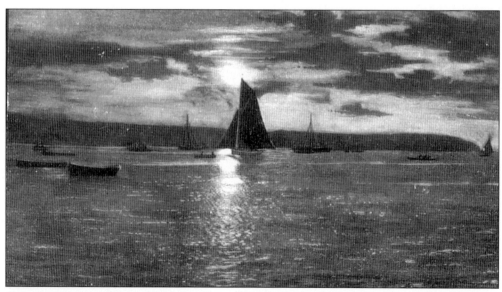

ON THE PACIFIC, SANTA MONICA, CAL. (Illustrated Postal Card Co., New York & Leipzig. No. 74. Postmark: February 1907.)

Three
SANTA MONICA
BUILDINGS AND STRUCTURES

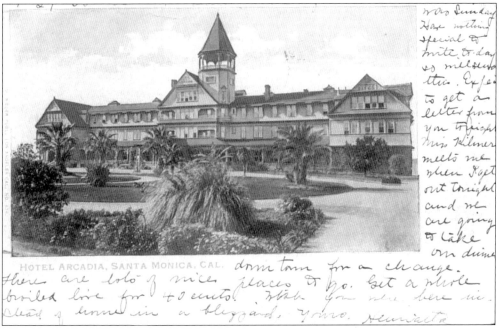

HOTEL ARCADIA, SANTA MONICA, CAL. (M. Rieder, Los Angeles. No. 678. Postmark: January 1905.)

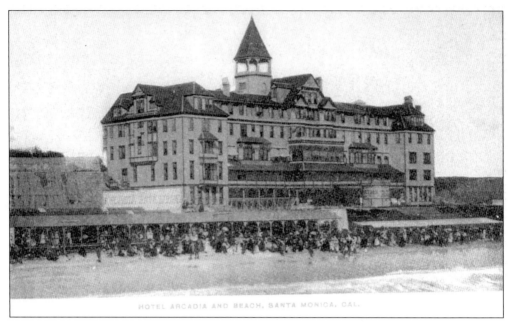

HOTEL ARCADIA AND BEACH, SANTA MONICA, CAL. (Edward H. Mitchell, San Francisco. No. 113.)

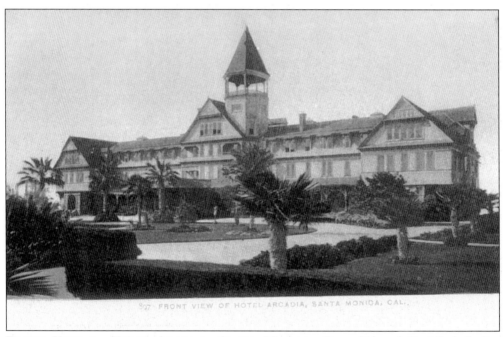

FRONT VIEW OF HOTEL ARCADIA, SANTA MONICA, CAL. (Edward H. Mitchell, San Francisco. No. 897. Postmark: October 1907.)

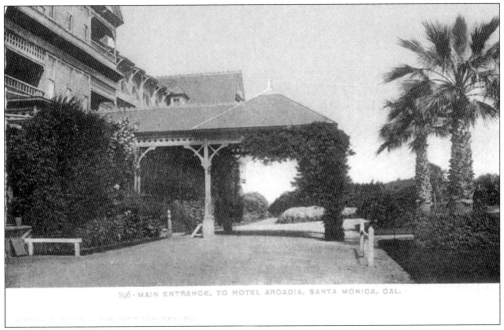

MAIN ENTRANCE, TO HOTEL ARCADIA, SANTA MONICA, CAL. (Edward H. Mitchell, San Francisco. No. 896.)

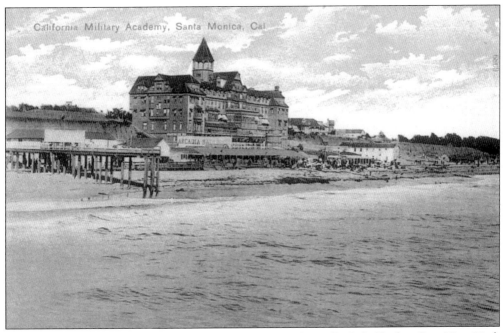

CALIFORNIA MILITARY ACADEMY, SANTA MONICA, CAL. (Paul C. Koeber Co., New York & Kirchheim Germany. No. 6989.)

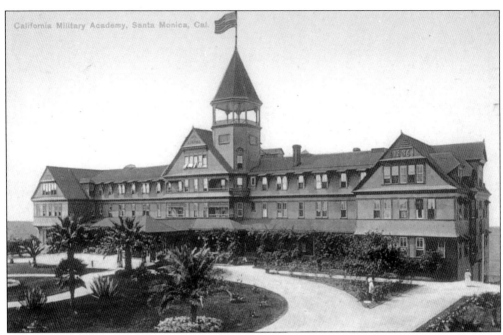

CALIFORNIA MILITARY ACADEMY, SANTA MONICA, CAL. (Newman Post Card Co., Los Angeles. No. F10.)

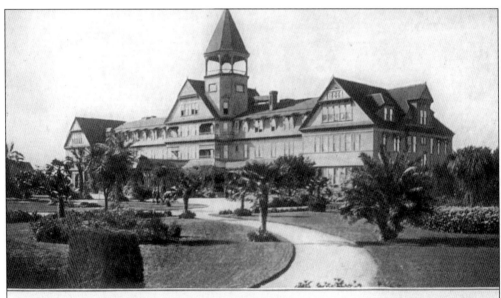

CALIFORNIA MILITARY ACADEMY, SANTA MONICA, LOS ANGELES COUNTY, CAL. 'Strictly Military. Prepares for all Colleges, for Business and for Foreign Travel. Only in this section situated directly on the Ocean Front. Catalogue on application.' (Woods, Los Angeles.)

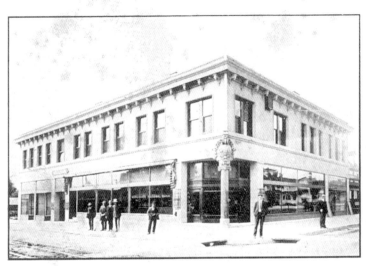

MERCHANTS NATIONAL BANK, DUDLEY BUILDING, SANTA MONICA, CAL. (Merchants National Bank.)

SANTA MONICA LODGE NO. 906. B.P.O. ELKS, SANTA MONICA, CALIFORNIA. (Geo. Rice & Sons, Printers, Los Angeles.)

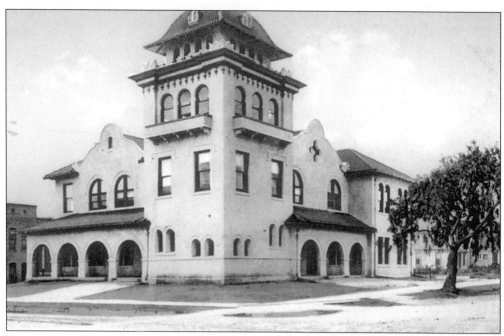

SANTA MONICA, CAL. CITY HALL. (Paul C. Koeber, New York & Kirchheim [Germany], No. 4065.)

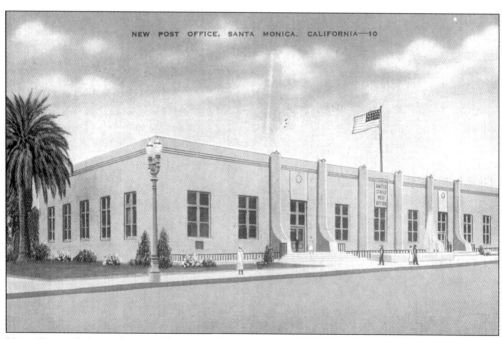

NEW POST OFFICE, SANTA MONICA, CALIFORNIA. (Bay News Co., Ocean Park, Calif. No. 10.)

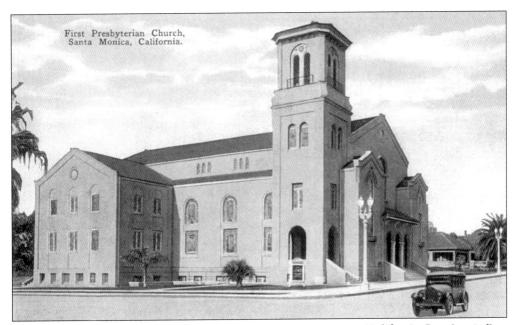

FIRST PRESBYTERIAN CHURCH, SANTA MONICA, CALIFORNIA (California Greeting & Post Card Co., Los Angeles. No. 314N.)

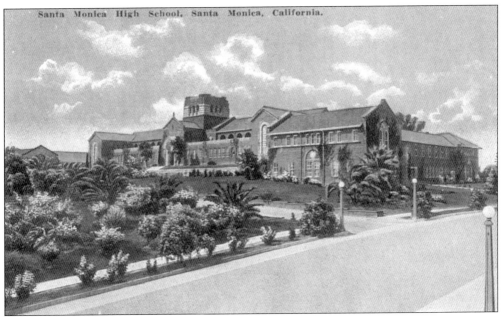

SANTA MONICA HIGH SCHOOL, SANTA MONICA, CALIFORNIA. (California Postcard Co., Los Angeles. No. 25123N.)

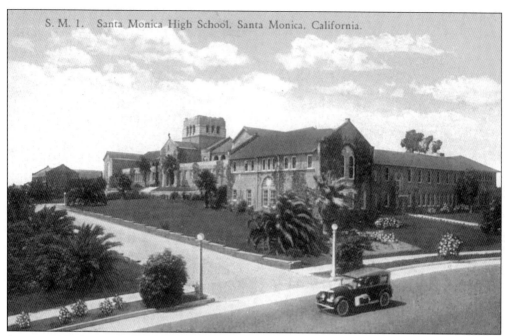

Santa Monica High School, Santa Monica, California. (Western Publishing & Novelty Co., Los Angeles. No. S.M.1.)

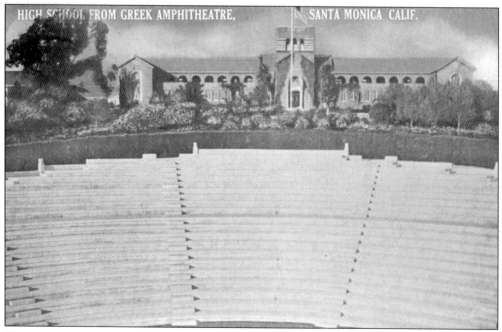

High School from Greek Theatre, Santa Monica, California. (Pacific Novelty Co., San Francisco & Los Angeles. No. F162.)

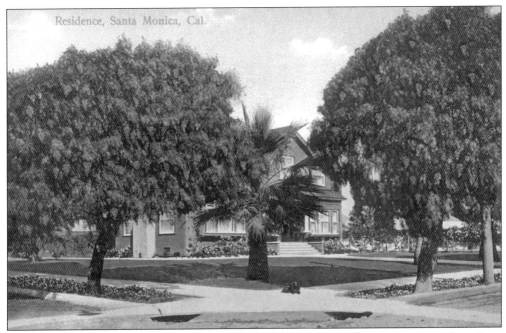

RESIDENCE, SANTA MONICA, CAL. A typical home in this beautiful ocean city where comfortable homes, broad well-kept streets, bordered by generous shade-trees are the rule. (M. Rieder, Los Angeles. No. 4623. Made in Germany.)

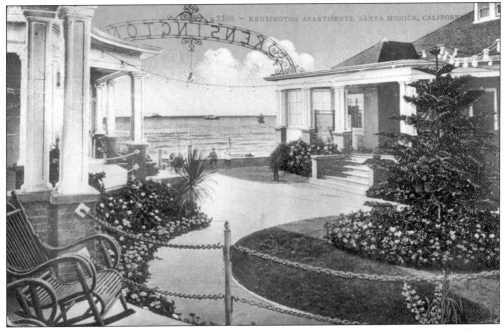

KENSINGTON APARTMENTS, SANTA MONICA, CALIFORNIA. (Edward H. Mitchell, San Francisco. No. 2306. Postmark: July 1910.)

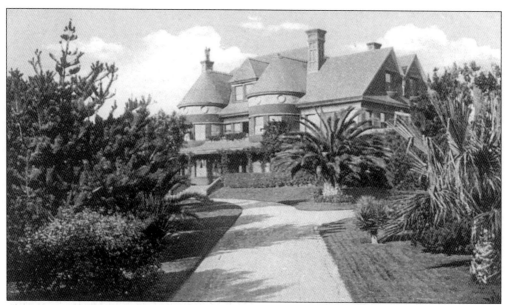

A SANTA MONICA RESIDENCE. (Detroit Publishing Co. No. 7869.)

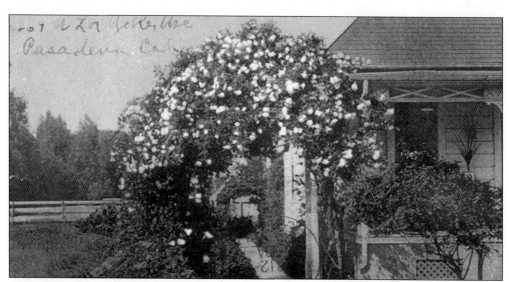

THE ROSE ARCH, SANTA MONICA, CAL. (Edward H. Mitchell, San Francisco. No. 805. Postmark: March 1907.)

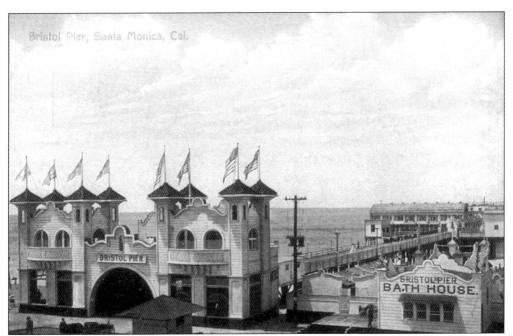

BRISTOL PIER, SANTA MONICA, CAL. (Newman Post Card Co., Los Angeles. No. F3. Made in Germany.)

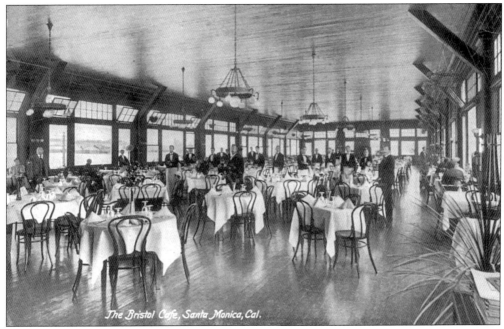

THE BRISTOL CAFÉ, SANTA MONICA, CAL. (M. Rieder, Los Angeles. No. 4791. Made in Germany.)

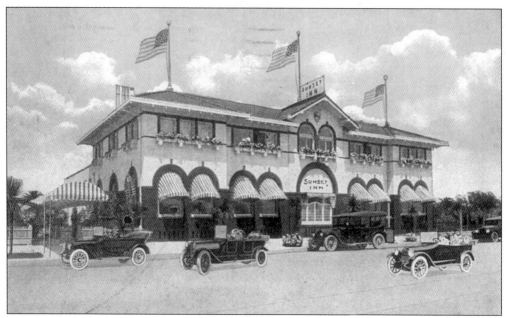

THE SUNSET INN, RESTAURANT FRANCAISE, SANTA MONICA BY THE SEA, CALIFORNIA. (E.C. Kropp, Milwaukee. No. 24524N. Postmark: January 1925.)

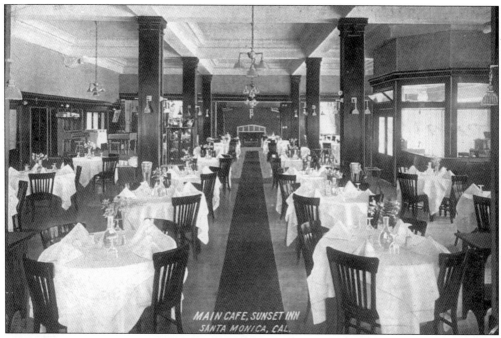

MAIN CAFÉ, SUNSET INN, SANTA MONICA, CAL. (Geo. Rice & Sons, Los Angeles. Postmark: August 1913.)

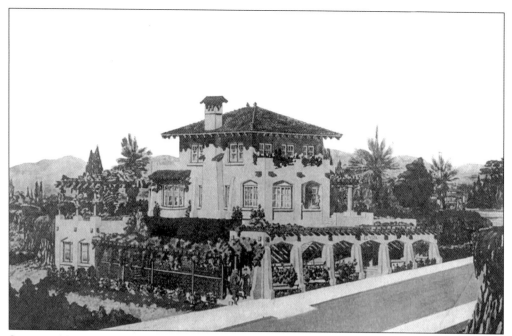

SEASIDE TERRACE. 'A visit to Seaside Terrace "between trolleys and sea" on ocean front promenade Santa Monica, California, will convince you it is the most "Beautiful Spot" in Southern California, which means the world.' ("Wood's" Post Cards, Los Angeles.)

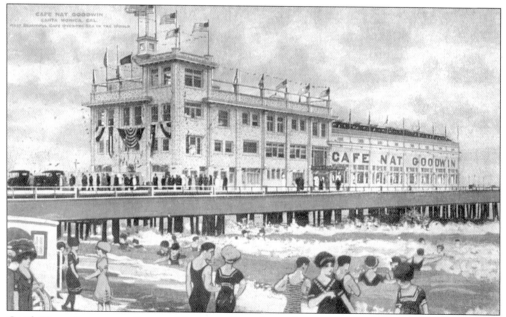

CAFÉ NAT GOODWIN, SANTA MONICA, CAL. 'Most beautiful café over-the-sea in the world. High class Cabaret. Rendezvous for Epicureans.' (Geo. Rice & Sons, Los Angeles. Postmark: January 1916.)

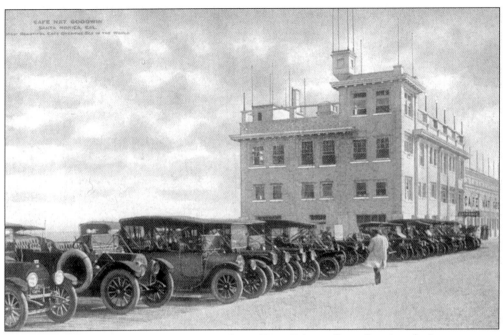

Café Nat Goodwin, Santa Monica, Cal. (Geo. Rice & Sons, Los Angeles.)

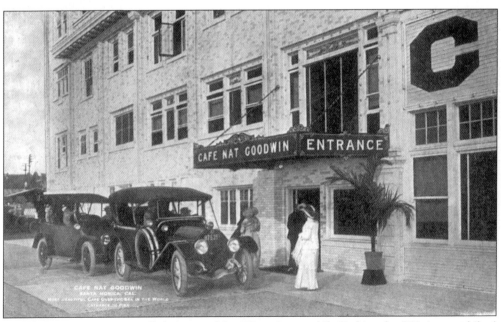

Café Nat Goodwin. 'Café de Luxe of the West. Automobile Parking for 350 Automobiles.' (Geo. Rice & Sons, Los Angeles.)

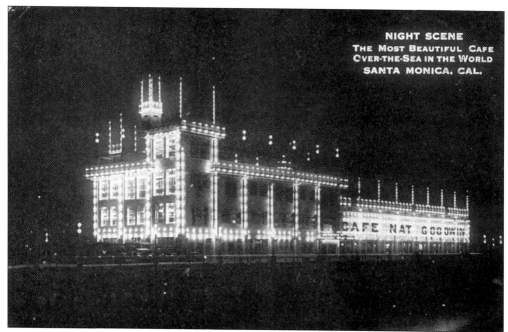

NIGHT SCENE, THE MOST BEAUTIFUL CAFÉ OVER-THE-SEA IN THE WORLD, SANTA MONICA, CAL. (Geo. Rice & Sons, Los Angeles. Postmark: February 1916.)

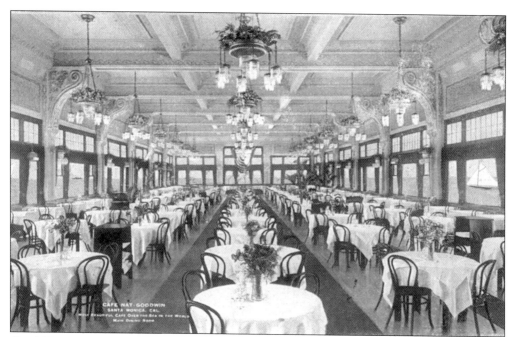

CAFÉ NAT GOODWIN, MAIN DINING ROOM. (Geo. Rice & Sons, Los Angeles. Postmark: June 1916.)

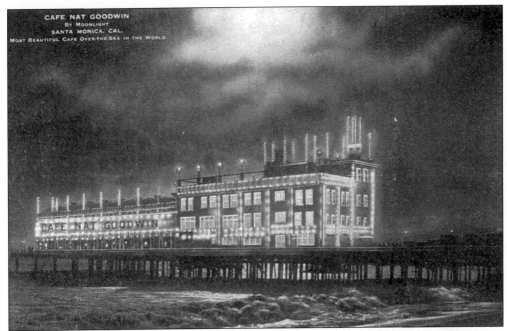

Café Nat Goodwin by Moonlight. 'High class Cabaret. Never a dull moment.' (Geo. Rice & Sons, Los Angeles.)

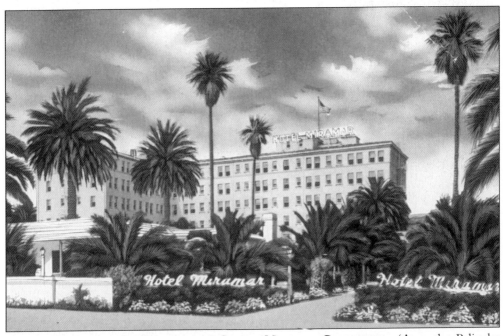

Hotel Miramar and Bungalows, Santa Monica, California. 'Atop the Palisades overlooking the blue Pacific Ocean. Turquoise Swimming Pool; spacious gardens; beautiful flowers. From $8.00 to $25.00. European plan.' (Colorpicture, Boston & Los Angeles.)

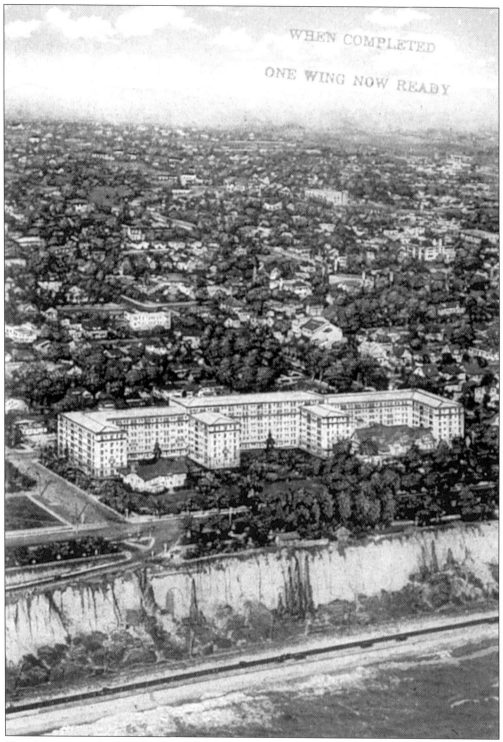

THE MIRAMAR, SANTA MONICA, CALIF., NEAREST BEACH HOTEL TO LOS ANGELES. (Curt Teich, Chicago. No. A96084)

Hotel Grounds from Veranda of Miramar Hotel, Santa Monica, Calif. (M. Kashower Co., Los Angeles. No. 17588. No. 318.)

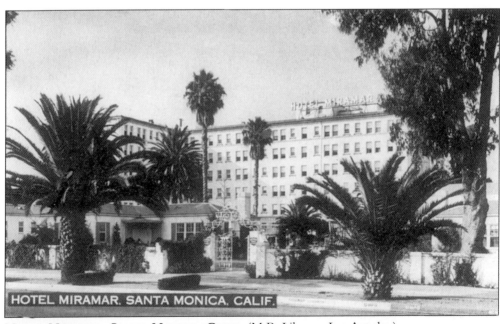

Motel Miramar, Santa Monica, Calif. (M.B. Libman, Los Angeles.)

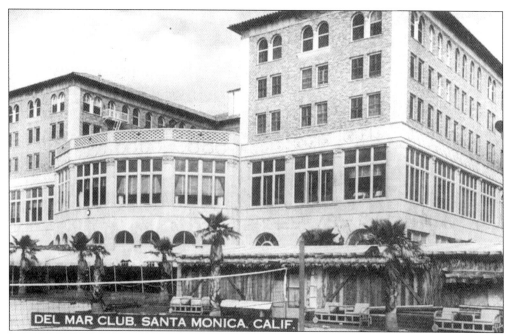

DEL MAR CLUB, SANTA MONICA, CALIF. (M.B. Libman, Los Angeles.)

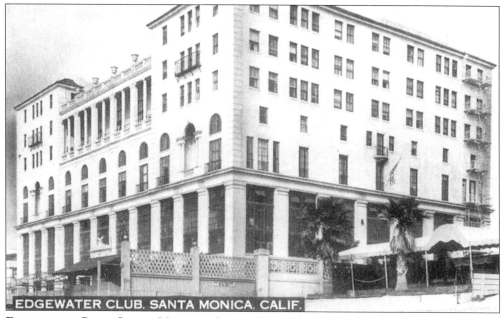

EDGEWATER CLUB, SANTA MONICA, CALIF. (M.B. Libman, Los Angeles.)

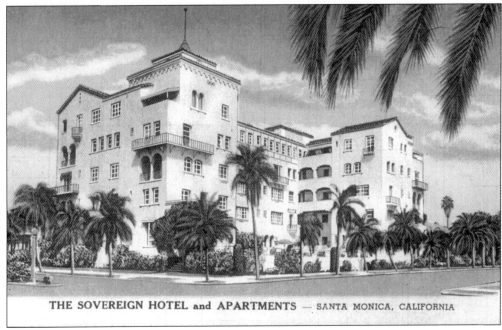

THE SOVEREIGN HOTEL AND APARTMENTS, SANTA MONICA, CALIFORNIA. 'On the Shores of the Blue Pacific.' (Curt Teich, Chicago.)

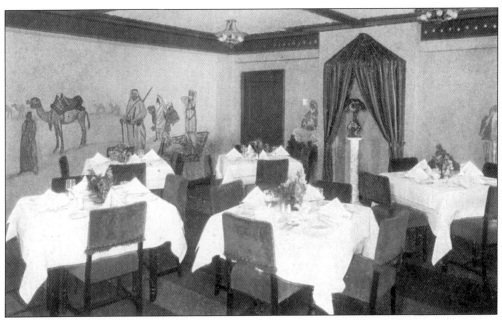

THE ARABIAN ROOM, THE BREAKERS CLUB, SANTA MONICA, CALIFORNIA. (E.C. Kropp Co., Milwaukee. No. 7709N.)

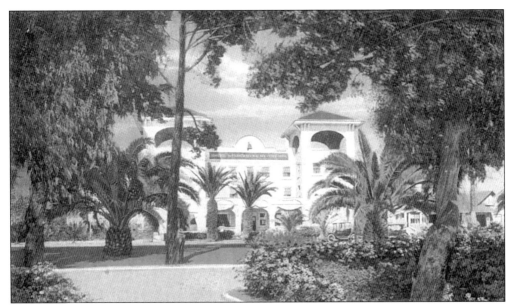

Hotel Windermere By-the-Sea, Santa Monica, California. 'Telephone 23291.' (E. C. Kropp Co., Los Angeles. No. 23092, Postmark: August 1930.)

Merritt Jones Hotel, Ocean Park, Cal. 'Spend an Enjoyable Summer at the Seaside. Cool Breezes. Surf Bathing.' (Geo. Rice & Sons, Los Angeles. Postmark: May 1914.)

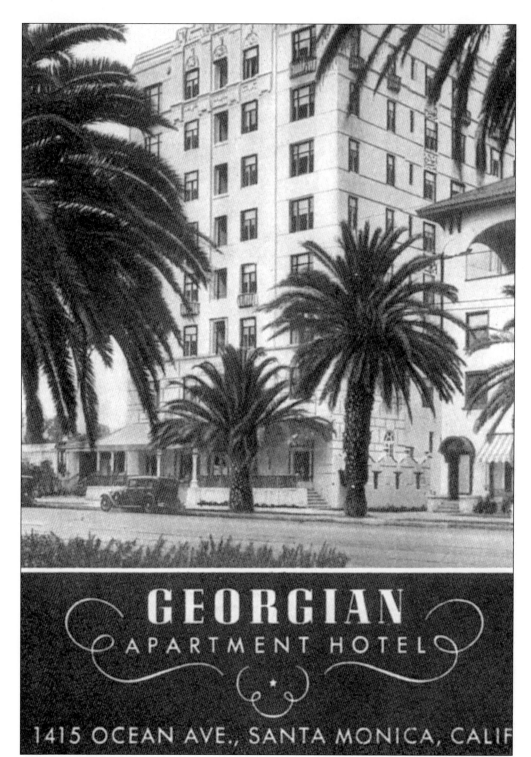

GEORGIAN APARTMENT HOTEL. '1415 Ocean Ave., Santa Monica, Calif.' (Georgian Hotel, Santa Monica. Postmark: June 1943.)

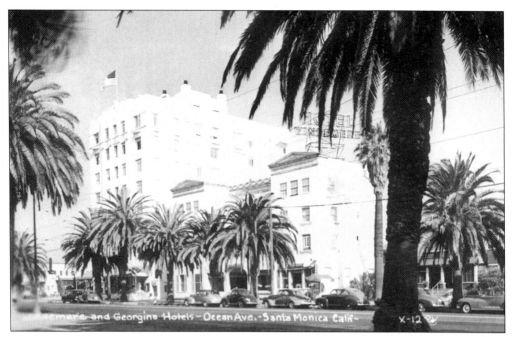

WINDERMERE AND GEORGIAN HOTELS, OCEAN AVE., SANTA MONICA, CALIF. (Unknown. No. X-12.)

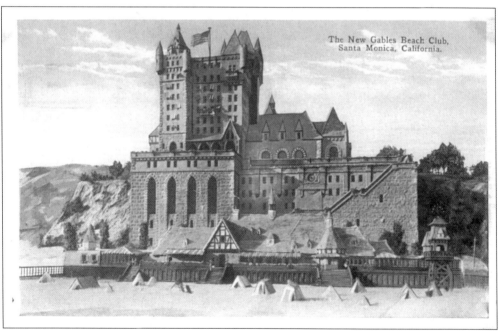

THE NEW GABLES BEACH CLUB, SANTA MONICA, CALIFORNIA. (California Greeting & Post Card Co., Los Angeles. No. 10222.)

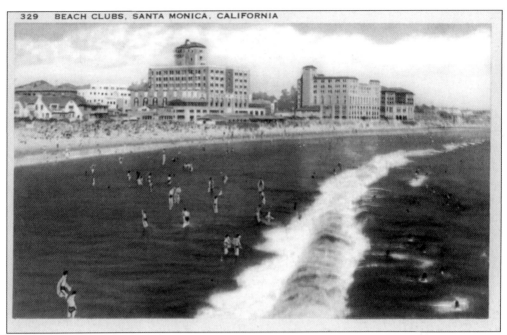

BEACH CLUBS, SANTA MONICA, CALIFORNIA. The mild climate of Santa Monica makes it ideal for bathing and outdoor life the year round. (Longshaw Card Co., Los Angeles. No. 329.)

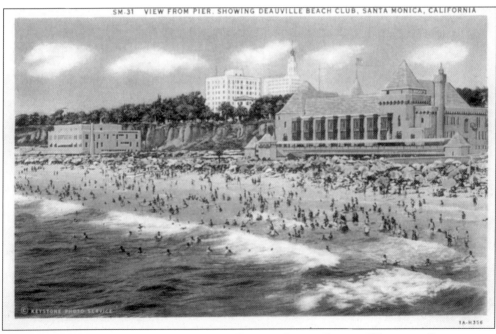

VIEW FROM PIER SHOWING DEAUVILLE BEACH CLUB, SANTA MONICA, CALIFORNIA. (Western Publishing & Novelty Co., Los Angeles. No. S.M.31.)

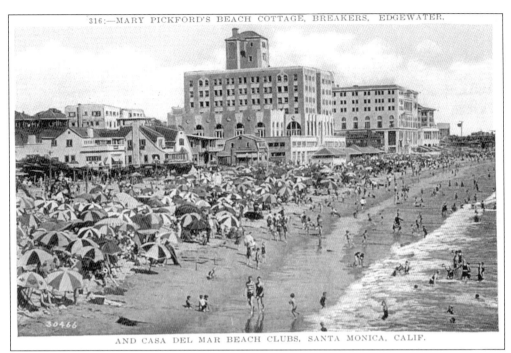

Mary Pickford's Beach Cottage, Breakers, Edgewater and Casa del Mar Beach Clubs, Santa Monica, Calif. (M. Kashower Co., Los Angeles. No. 316.)

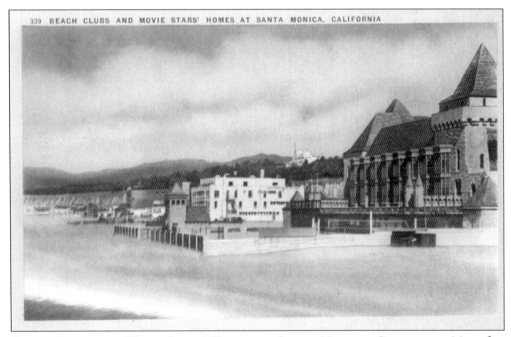

Beach Clubs and Movie Stars' Homes at Santa Monica, California. Many fine beach clubs have been established at Santa Monica because of its continual moderate climate and beautiful shores, and excellent yacht harbor. (Longshaw Card Co., Los Angeles. No. 339.)

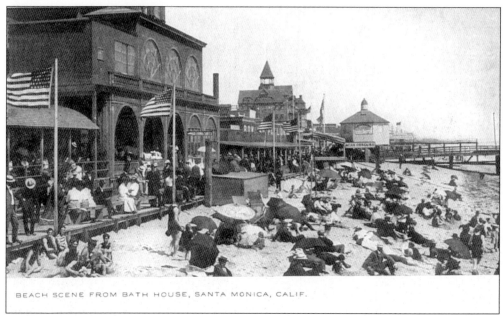

BEACH SCENE FROM BATH HOUSE, SANTA MONICA, CALIF.

BEACH SCENE FROM BATH HOUSE, SANTA MONICA, CALIF. (Walt. M. Reeves, Mission Artist, Los Angeles.)

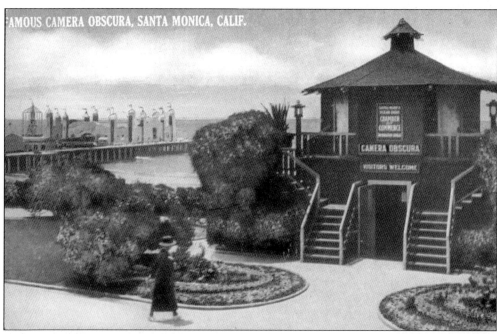

FAMOUS CAMERA OBSCURA, SANTA MONICA, CALIF. 'Was made by Robert F. Jones, he being a nephew of the late Senator John P. Jones, the founder of the City of Santa Monica. It was given to the City of Santa Monica in 1907 and is operated by the Santa Monica-Ocean Park Chamber of Commerce. To the left is the beautiful La Monica Ballroom. The United States Good Roads Convention will be held in Santa Monica, June 7–12, 1926.' (Pacific Novelty Co., Los Angeles. Courtesy Lee Brown, Adventure in Postcards.)

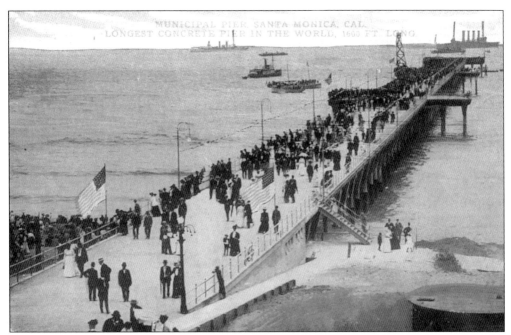

MUNICIPAL PIER, SANTA MONICA, CALIFORNIA, LONGEST CONCRETE PIER IN THE WORLD, 1600 FT. LONG. (Santa Monica Bay Chamber of Commerce. No. 10175)

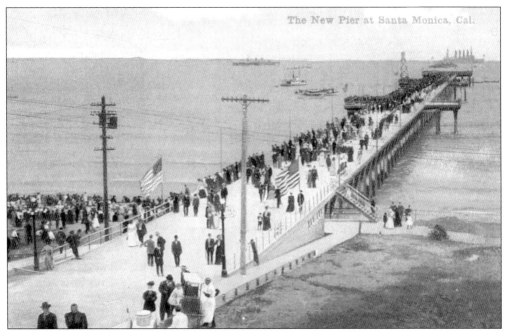

THE NEW PIER AT SANTA MONICA, CAL. (Souvenir Publishing Co., Los Angeles & San Francisco. No. F10.)

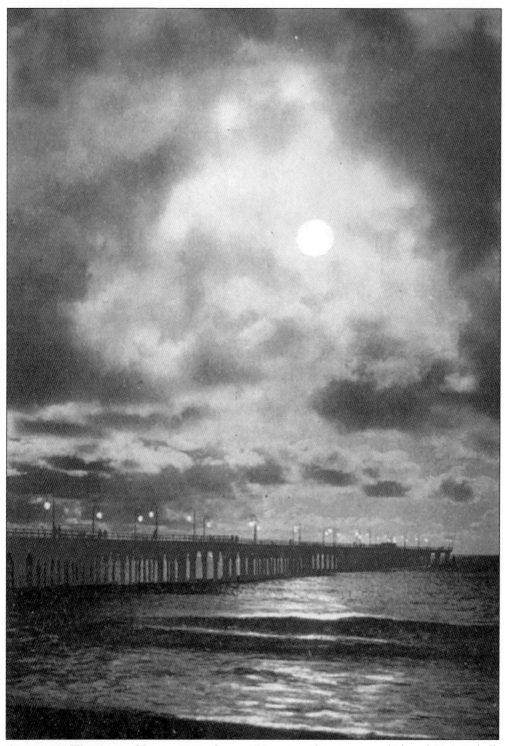

CONCRETE WHARF BY MOONLIGHT, SANTA MONICA, CALIFORNIA. (Edward H. Mitchell, San Francisco. No. 2513.)

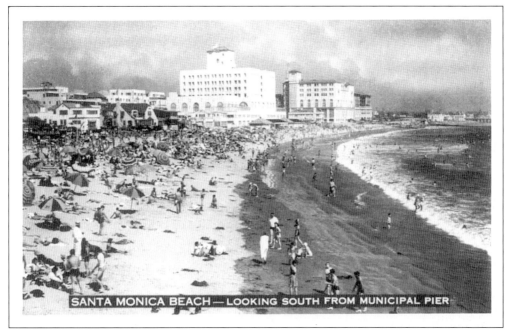

THE LOOP AND MUNICIPAL PIERS, SANTA MONICA, CALIF. (Pacific Novelty Co., San Francisco & Los Angeles. No. F173.)

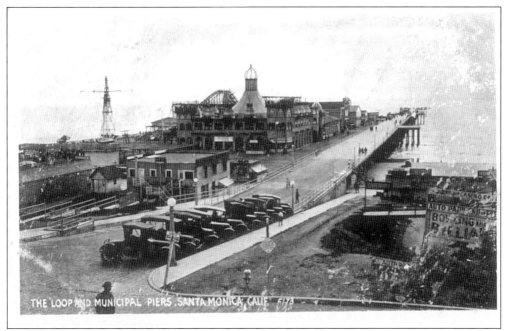

SANTA MONICA BEACH, LOOKING SOUTH FROM MUNICIPAL PIER. (M.B. Libman, Los Angeles.)

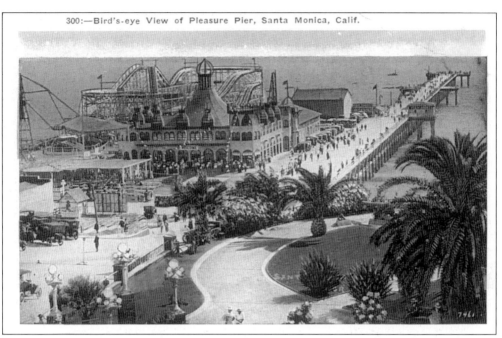

Bird's-eye View of Pleasure Pier, Santa Monica, Calif. (M. Kashower Co., Los Angeles. No. 300.)

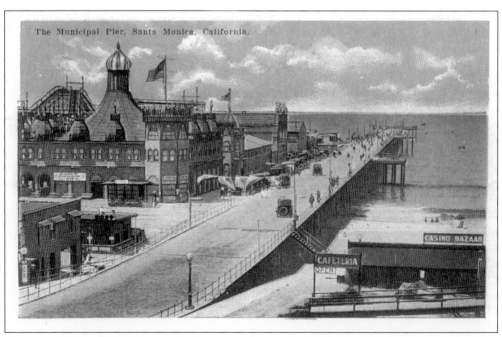

The Municipal Pier, Santa Monica, California. (California Postcard Co., Los Angeles. No. 25128N. Postmark: May 1925.)

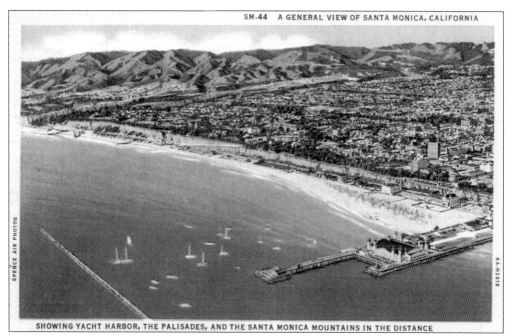

A GENERAL VIEW OF SANTA MONICA, CALIFORNIA, SHOWING YACHT HARBOR, THE PALISADES, AND THE SANTA MONICA MOUNTAINS IN THE DISTANCE. (Western Publishing & Novelty Co., Los Angeles. No. S.M.44. Postmark: October 1950.)

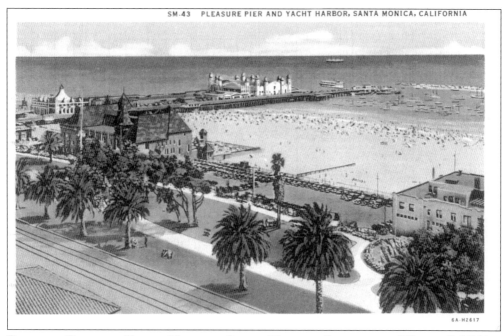

PLEASURE PIER AND YACHT HARBOR, SANTA MONICA, CALIFORNIA. (Western Publishing & Novelty Co., Los Angeles. No. S.M.43. Postmark: August 1940.)

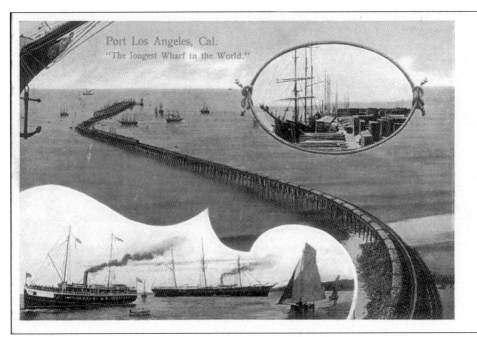

PORT LOS ANGELES, CAL. "THE LONGEST WHARF IN THE WORLD." (M. Rieder, Los Angeles. No. 3043. Made in Germany. Postmark: September 1907.)

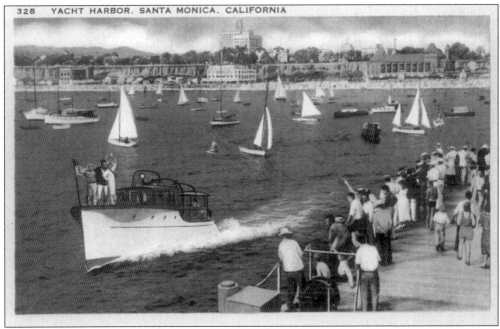

YACHT HARBOR, SANTA MONICA, CALIFORNIA. Santa Monica, with its great natural harbor, plays host to some of the finest yachts in the world, and the municipal harbor offers a picturesque sight of marine activity. (Longshaw Card Co., Los Angeles. No. 328.)

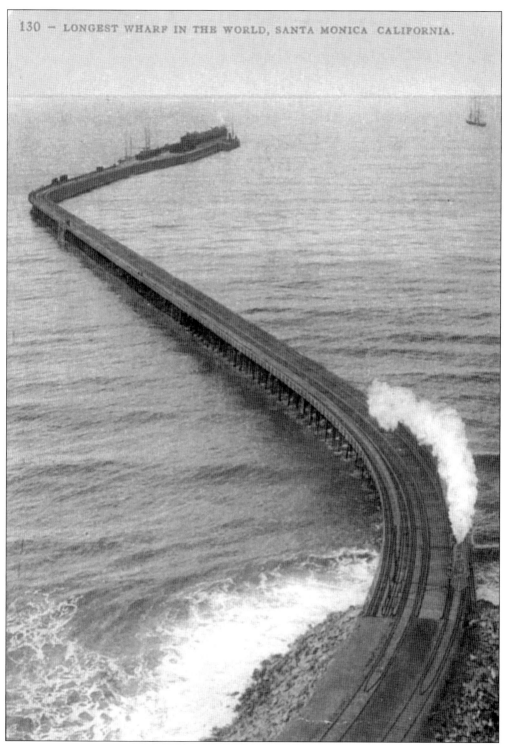

LONGEST WHARF IN THE WORLD, SANTA MONICA, CALIFORNIA. (Edward H. Mitchell, San Francisco. No. 130.)

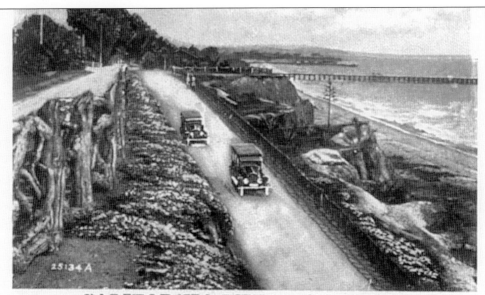

CALIFORNIA THE BEAUTIFUL
On the shores of California
 The sweetest breezes blow,
'Tis here the fairest flowers bloom,
 The brightest sunsets glow.
'Tis here in sweet tranquility
 And balmy summer air
That we are free from frost and storm
 And Eastern wintry care.

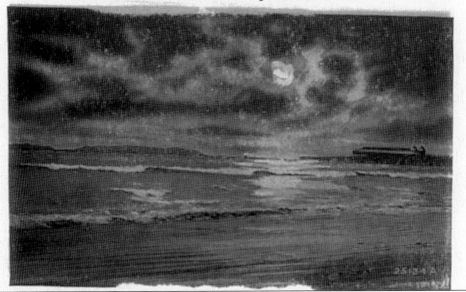

THE PALISADES, SANTA MONICA. MOONLIGHT ON THE PACIFIC. (M. Kashower Co., Los Angeles. No. 25134A.)

Four
Santa Monica
Sights

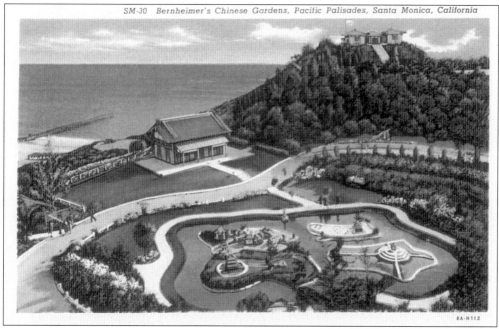

Bernheimer's Chinese Gardens, Pacific Palisades, Santa Monica, California.
(Western Publishing & Novelty Co., Los Angeles. No. S.M.30.)

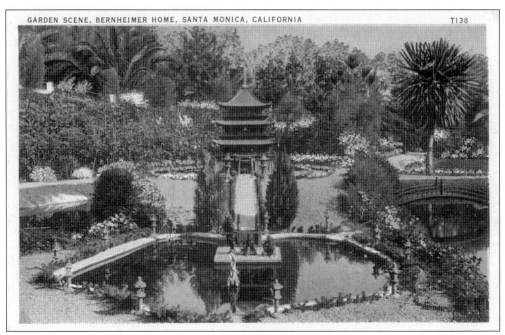

GARDEN SCENE, BERNHEIMER HOME, SANTA MONICA, CALIFORNIA. A part of the most unique and interesting miniature Asiatic Statuary found anywhere other than the Orient. (Tichnor Art Co., Los Angeles. No. T138.)

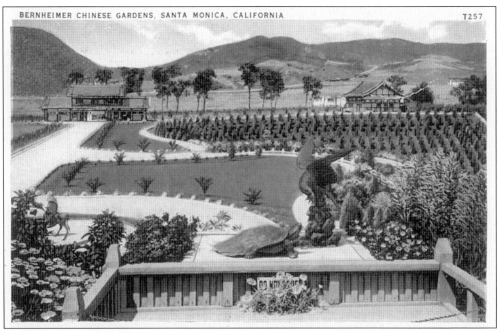

BERNHEIMER CHINESE GARDENS, SANTA MONICA, CALIFORNIA. (Tichnor Art Co., Los Angeles. No. T257. Postmark: December 1936.)

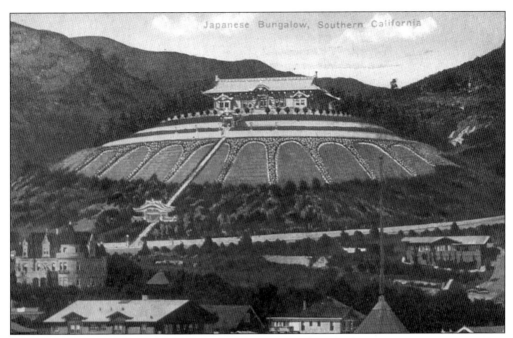

JAPANESE BUNGALOW, SOUTHERN CALIFORNIA. (Pacific Novelty Co., San Francisco & Los Angeles. No. A23.)

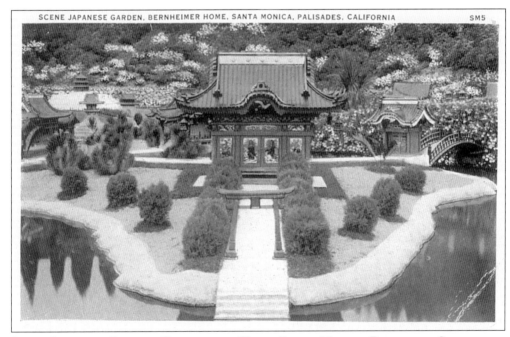

SCENE JAPANESE GARDEN, BERNHEIMER HOME SANTA MONICA PALISADES, CALIFORNIA. 'A breath of the Orient on the Palisades of Santa Monica.' (News Stand Distributors, Los Angeles. No. S.M.5. Postmark: May 1934.)

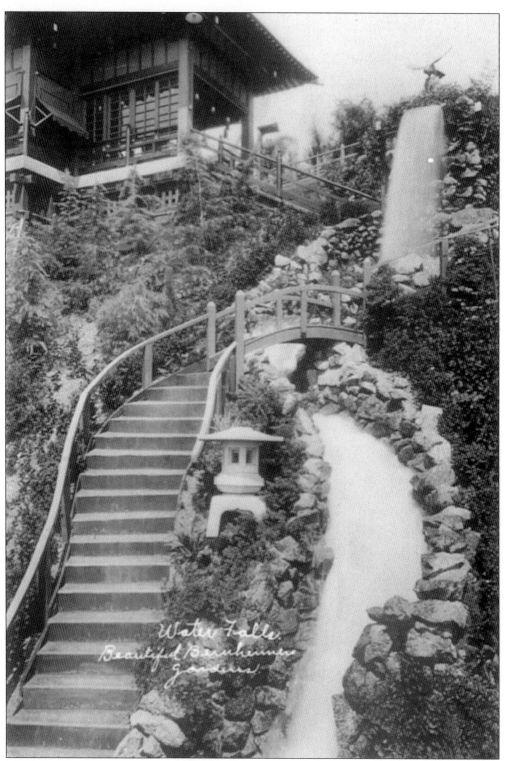

WATER FALLS, BEAUTIFUL BERNHEIMER GARDENS. (Unknown.)

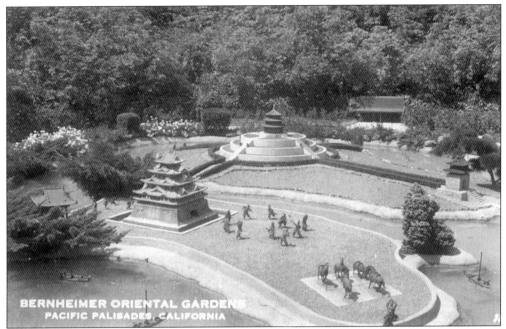

BERNHEIMER ORIENTAL GARDENS, PACIFIC PALISADES, CALIFORNIA. (Unknown. No. 11.)

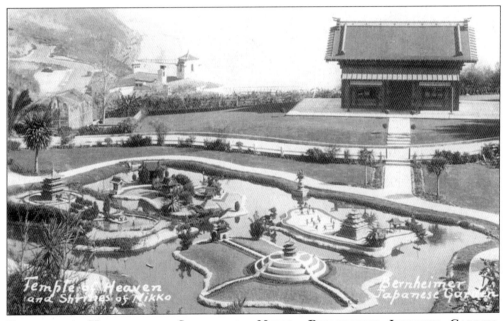

TEMPLES OF HEAVEN AND SHRINES OF NIKKO, BERNHEIMER JAPANESE GARDEN. (Unknown.)

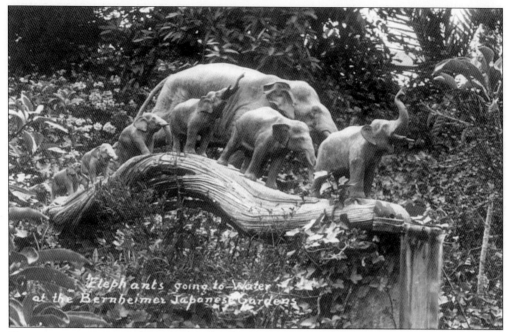

ELEPHANTS GOING TO WATER AT THE BERNHEIMER JAPANESE GARDENS. (Unknown.)

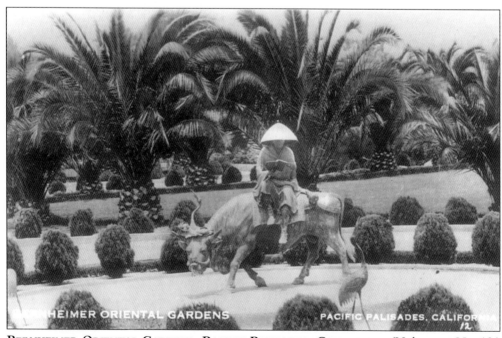

BERNHEIMER ORIENTAL GARDENS, PACIFIC PALISADES, CALIFORNIA. (Unknown. No. 12.)

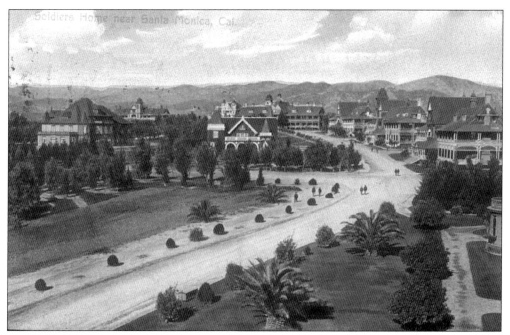

SOLDIERS HOME NEAR SANTA MONICA, CAL. (Newman Post Card Co., Los Angeles. No. F5. Made in Germany. Postmark: September 1908.)

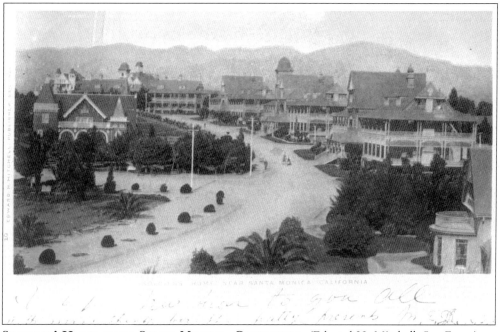

SOLDIERS' HOME, NEAR SANTA MONICA, CALIFORNIA. (Edward H. Mitchell, San Francisco. No. 26. Postmark: December 1905.)

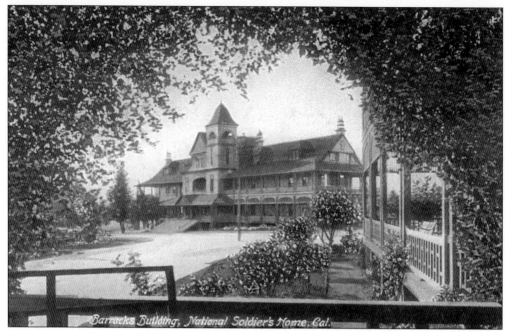

BARRACKS BUILDING, NATIONAL SOLDIER'S HOME, CAL. (George O. Restall, Los Angeles. No. S.H.3. Made in Germany. Postmark: October 1910.)

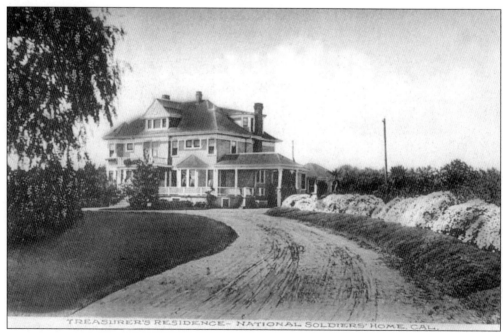

TREASURER'S RESIDENCE, NATIONAL SOLDIERS' HOME, CAL. (Unknown.)

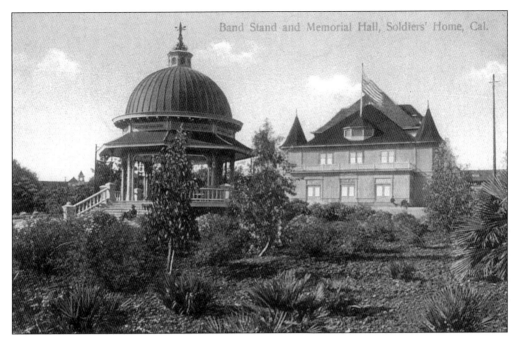

BAND STAND AND MEMORIAL HALL, SOLDIERS' HOME, CAL. (Published for Post Fund, Soldier's Home, Cal. Made in Germany. Dated: January, 1912.)

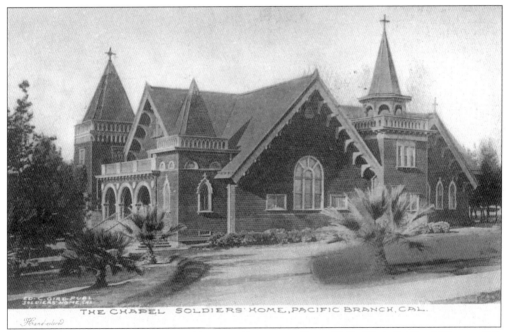

THE CHAPEL, SOLDIERS' HOME, PACIFIC BRANCH, CAL. (E.C. Gird, Soldiers' Home, Cal. Postmark: July 1907.)

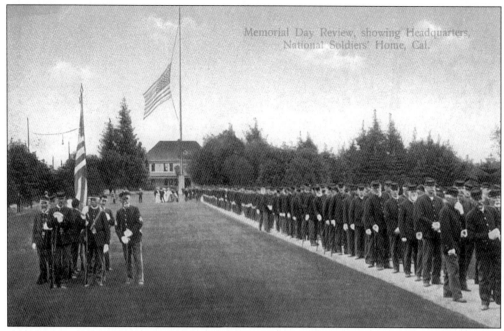

MEMORIAL DAY REVIEW, SHOWING HEADQUARTERS, NATIONAL SOLDIERS' HOME, CAL.
(Published for the Post Fund, Soldiers' Home, Cal. No. 65682.)

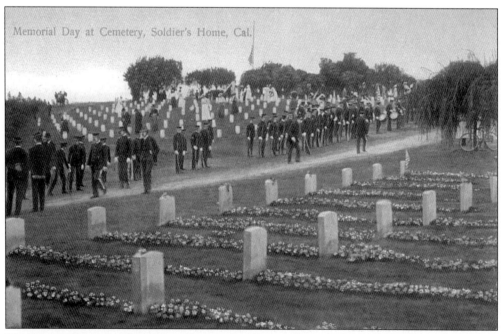

MEMORIAL DAY AT CEMETERY, SOLDIER'S HOME, CAL. (E.C. Gird, Soldier's Home, Cal. No. 58236. Made in Germany.)

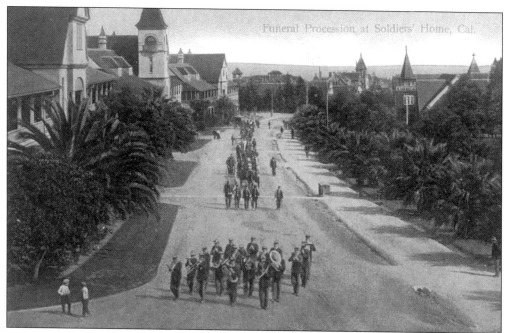

FUNERAL PROCESSION AT SOLDIERS' HOME, CAL. (Published for the Post Fund, Soldier's Home, Cal. No. 58232. Made in Germany.)

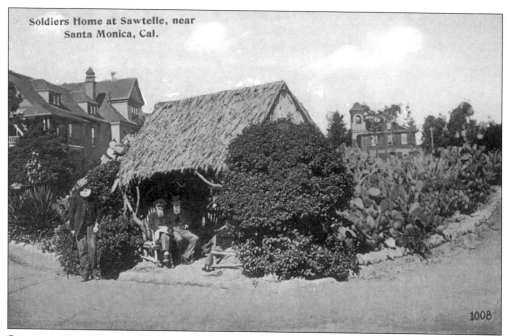

SOLDIERS HOME AT SAWTELLE, NEAR SANTA MONICA, CAL. (Tichnor Bros., Boston & Los Angeles. No. 1008. Postmark: August 1914.)

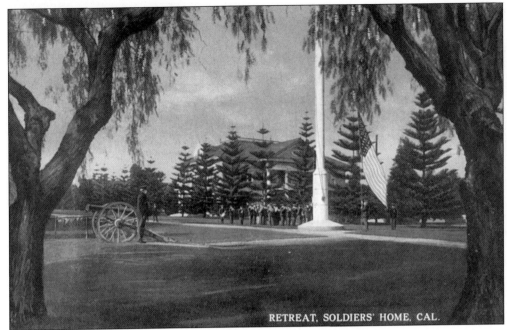

RETREAT, SOLDIER'S HOME, CAL. (Published for the Post Fund, Soldiers' Home, Cal. No. A52689.)

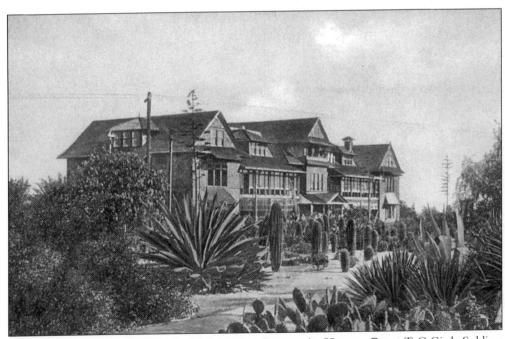

BARRACKS CO., L. AND CACTUS GARDEN, SOLDIER'S HOME, CAL. (E.C.Gird, Soldiers Home, Cal. No. 4684.)

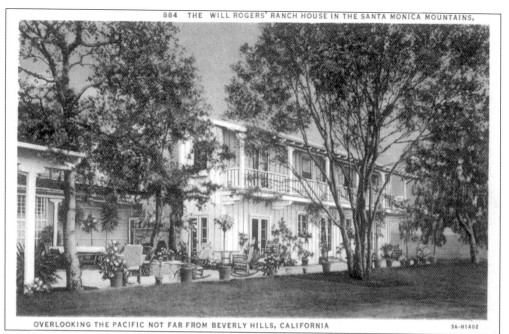

The Will Rogers' Ranch House in the Santa Monica Mountains, overlooking the Pacific not far from Beverly Hills, California. (Western Publishing & Novelty Co., Los Angeles. No. 884.)

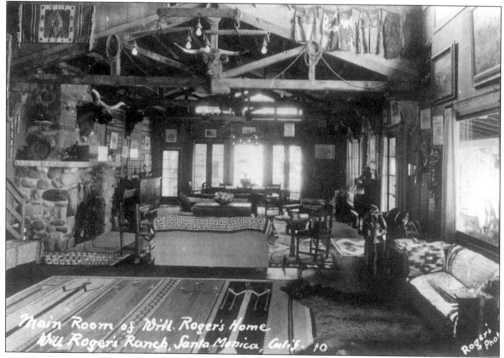

Main Room of Will Rogers' Home, Will Rogers' Ranch, Santa Monica, Calif. (Rogers' Photo. No. 10.)

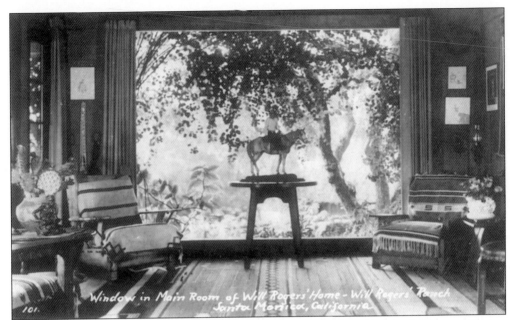

WINDOW IN THE MAIN ROOM OF WILL ROGERS' HOME, WILL ROGERS' RANCH, SANTA MONICA, CALIFORNIA. (Unknown. No. 101. Postmark: November 1943.

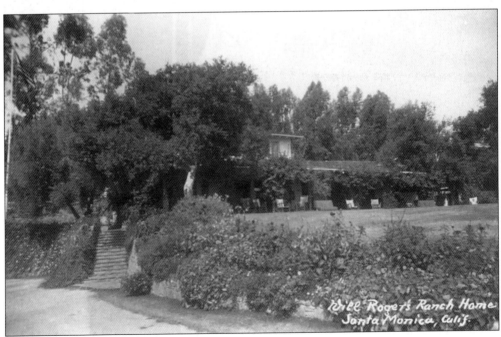

WILL ROGERS' RANCH HOME, SANTA MONICA, CALIF. (Unknown.)

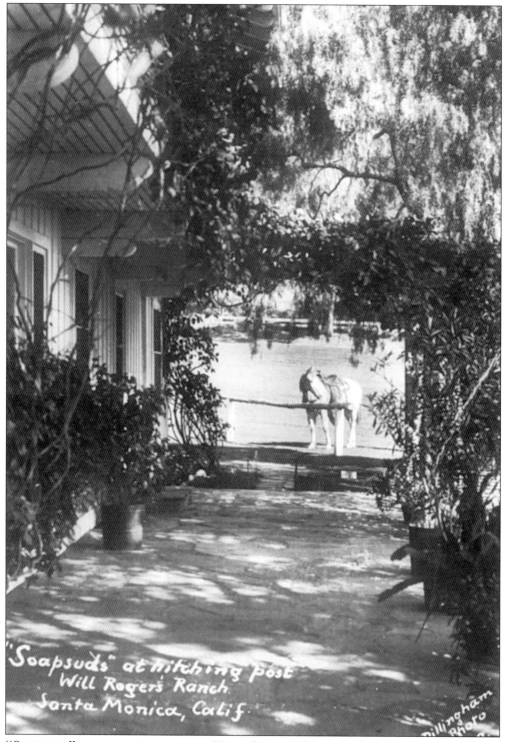

"Soapsuds" at hitching post, Will Rogers Ranch, Santa Monica, Calif.
(Dillingham Photo. No. 19.)

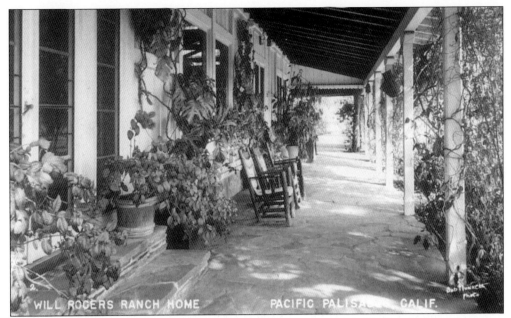

Will Rogers Ranch Home, Pacific Palisades, Calif. (Bob Plunkett Photo. No. 2.)

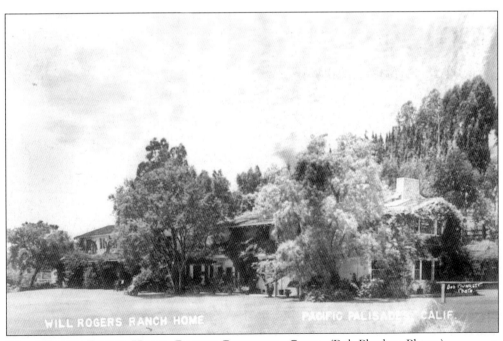

Will Rogers Ranch Home, Pacific Palisades, Calif. (Bob Plunkett Photo.)

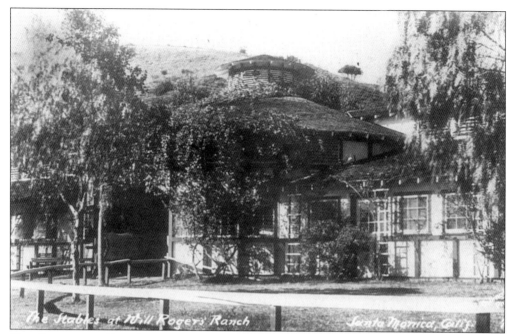

THE STABLES AT WILL ROGERS' RANCH, SANTA MONICA, CALIF. (Dillingham Photo. No. 7.)

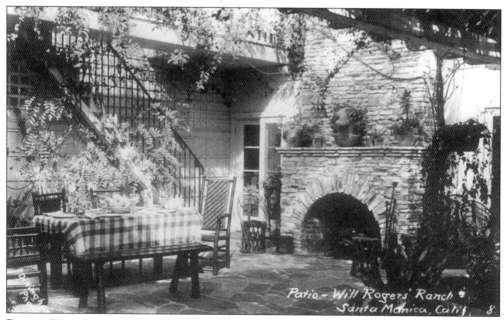

PATIO, WILL ROGERS' RANCH, SANTA MONICA, CALIF. (Dillingham Photo. No. 8.)

Santa Monica Display [Los Angeles County Fair or National Orange Show?] (Unknown.)

Five
Ocean Park
and Venice

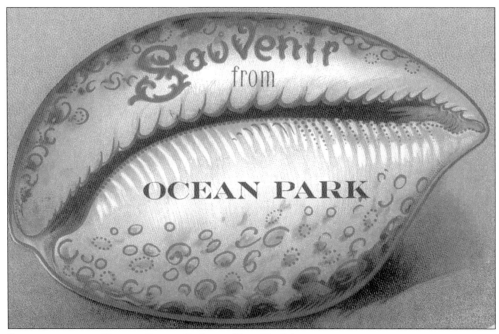

Souvenir from Ocean Park. (I. Stern, New York.)

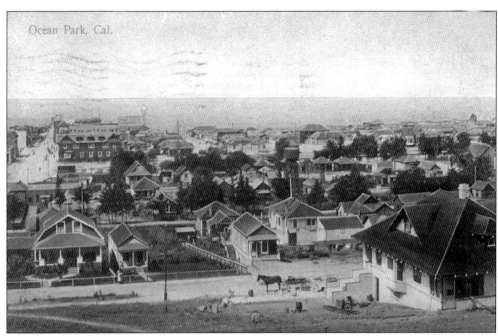

OCEAN PARK, CAL. (M. Rieder, Los Angeles. No. 3251. Postmark: August 1906.)

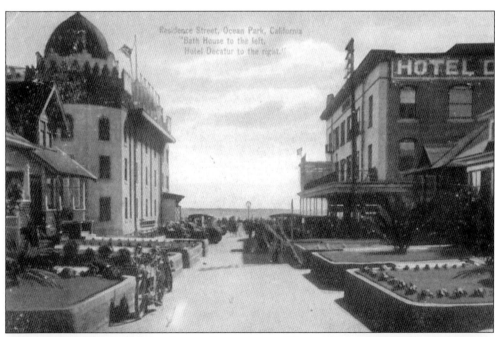

RESIDENCE STREET, OCEAN PARK, CALIFORNIA: "BATH HOUSE TO THE LEFT, HOTEL DECATUR TO THE RIGHT." (Newman Post Card Co., Los Angeles. No. F108.)

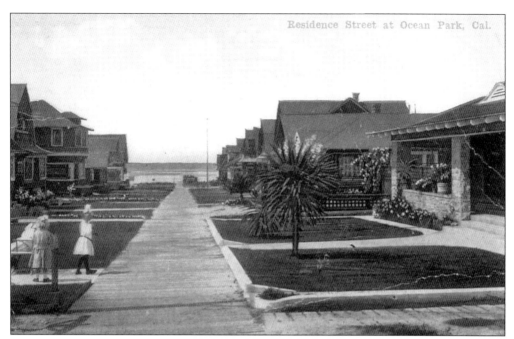

RESIDENCE STREET AT OCEAN PARK, CAL. (Newman Post Card Co., Los Angeles. No. F101. Postmark: November 1912.)

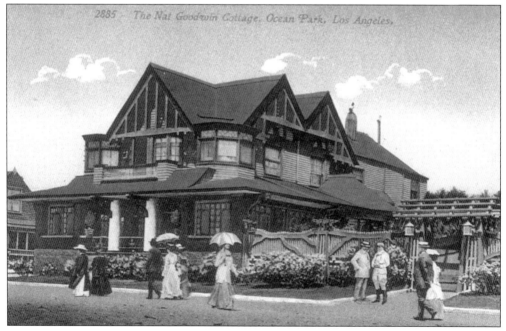

THE NAT GOODWIN COTTAGE, OCEAN PARK, LOS ANGELES. (Souvenir Publishing Co., San Francisco. No. 2885.)

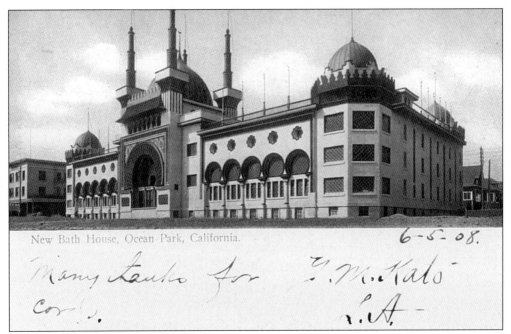

NEW BATH HOUSE, OCEAN PARK, CALIFORNIA. (M. Rieder, Los Angeles. No. 3297. Made in Germany. Dated: June 1908.)

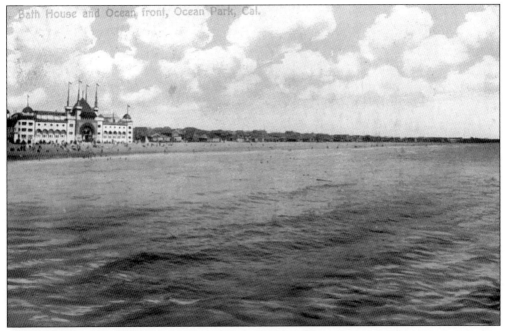

BATH HOUSE AND OCEAN FRONT, OCEAN PARK, CAL. (Newman Post Card Co., Los Angeles. No. 6219. Postmark: February 1908.)

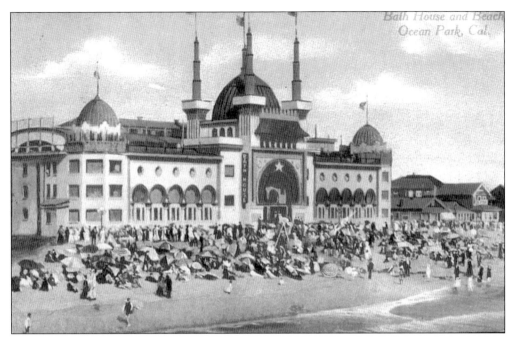

BATH HOUSE AND BEACH, OCEAN PARK, CAL. (Newman Post Card Co., Los Angeles & San Francisco. No. F121. Postmark: May 1910.)

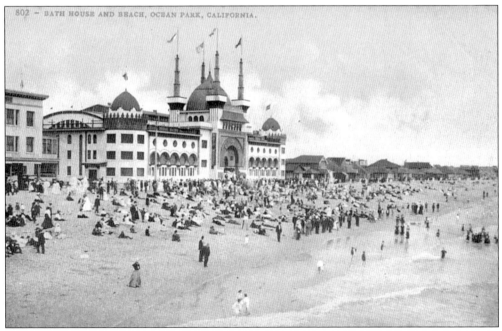

BATH HOUSE AND BEACH, OCEAN PARK, CALIFORNIA. (Edward H. Mitchell, San Francisco. No. 802.)

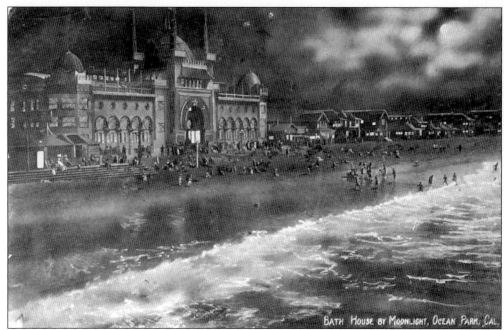

BATH HOUSE BY MOONLIGHT, OCEAN PARK, CAL. (Western Publishing & Novelty Co., Los Angeles. Postmark: August 1912.)

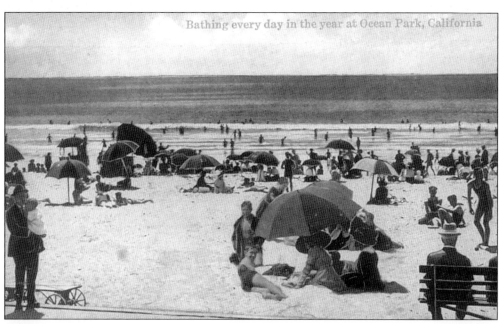

BATHING EVERY DAY IN THE YEAR AT OCEAN PARK, CALIFORNIA. (M. Kashower Co., Los Angeles. No. 532.)

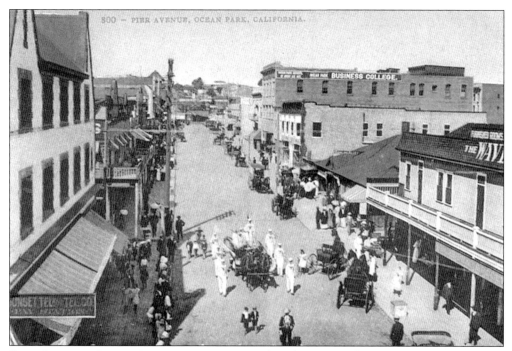

PINE AVENUE, OCEAN PARK, CALIFORNIA. (Edward H. Mitchell, San Francisco. No. 800.)

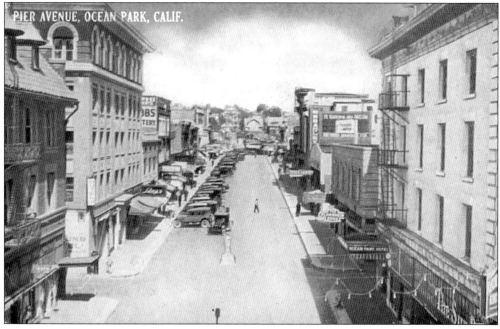

PIER AVENUE, OCEAN PARK, CALIF. (Pacific Novelty Co., San Francisco & Los Angeles. No. F119.)

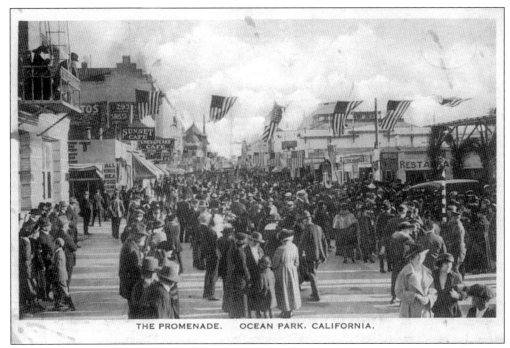

THE PROMENADE, OCEAN PARK, CALIFORNIA. (Western Publishing & Novelty Co., Los Angeles. No. 755.)

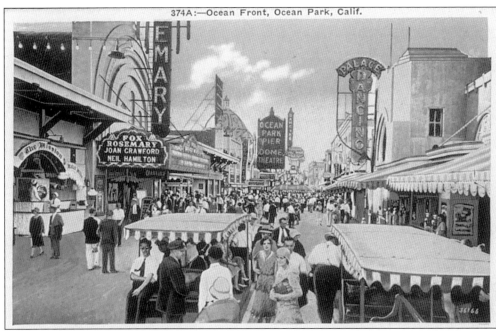

OCEAN FRONT, OCEAN PARK, CALIF. (M. Kashower Co., Los Angeles. No. 374A. Postmark: January 1942.)

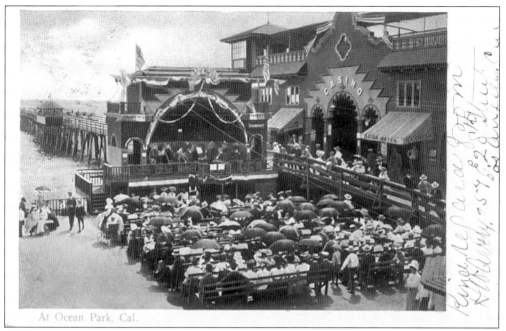

AT OCEAN PARK, CAL. (M. Rieder, Los Angeles. No. 3246. Made in Germany.)

ENTERTAINMENT IN FRONT OF AUDITORIUM, OCEAN PARK, CAL. (M. Kashower Co., Los Angeles. No. 424. Date: 1925.)

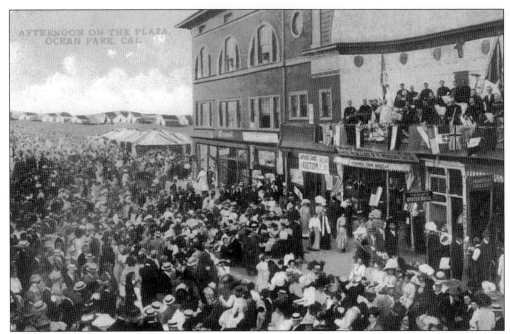

AFTERNOON ON THE PLAZA, OCEAN PARK, CAL. (Santa Monica Chamber of Commerce. No. 10173.)

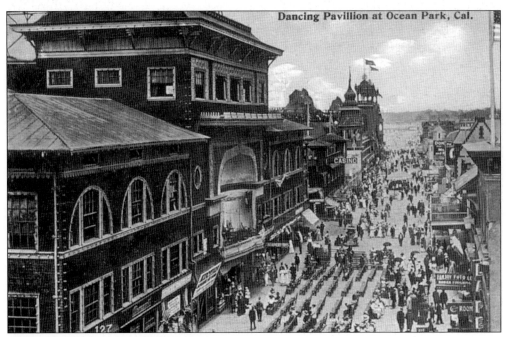

DANCING PAVILION AT OCEAN PARK, CAL. (Tichnor Bros., Boston. No. 127.)

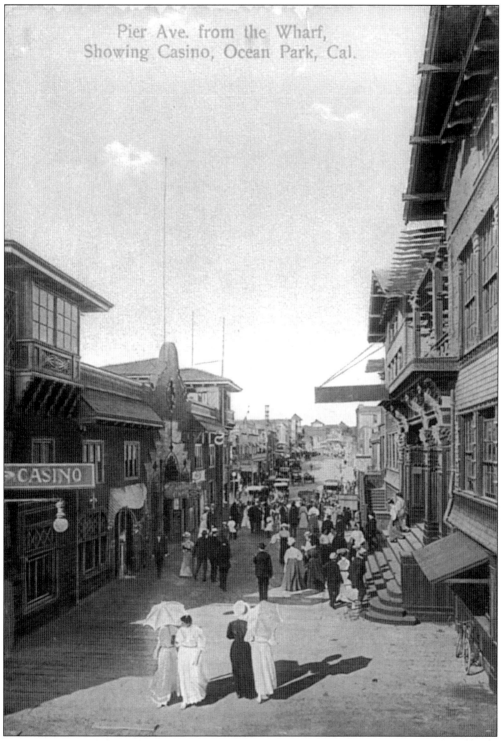

PIER AVE FROM THE WHARF, SHOWING CASINO, OCEAN PARK, CAL. (M. Rieder, Los Angeles. No. 4815. Made in Germany.)

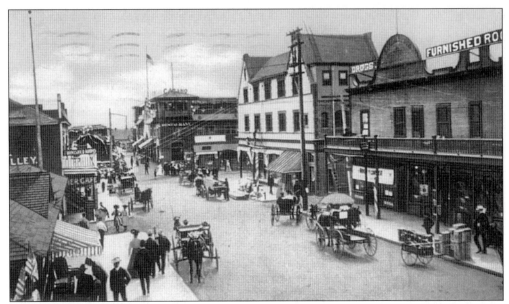

Pier Avenue, Ocean Park, Cal. (Detroit Publishing Co. No. 8704. Postmark: September 1910.)

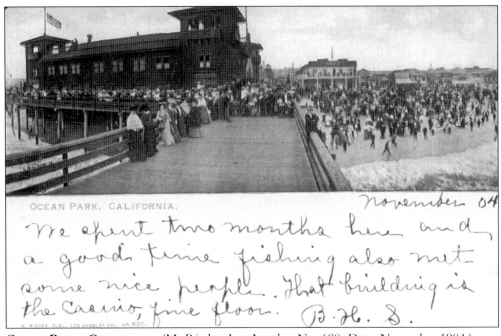

Ocean Park, California. (M. Rieder, Los Angeles. No. 680. Date: November 1904.)

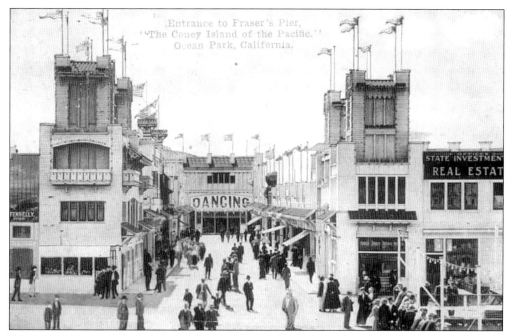

ENTRANCE TO FRASER'S PIER, "THE CONEY ISLAND OF THE PACIFIC," OCEAN PARK, CALIFORNIA. (VanOrnum Colorprint, Co., Los Angeles. No. 531. Postmark: July 1915.)

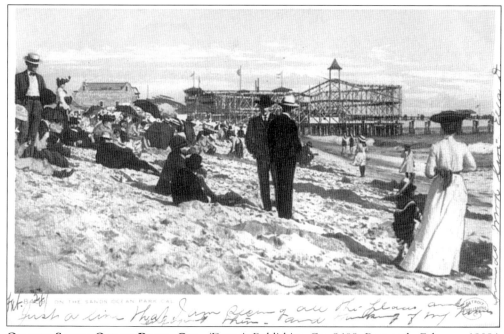

ON THE SANDS OCEAN PARK, CAL. (Detroit Publishing Co. 8409. Postmark: February 1908.)

OCEAN PARK. (Newman Post Card Co., Los Angeles & San Francisco. No. ?12.)

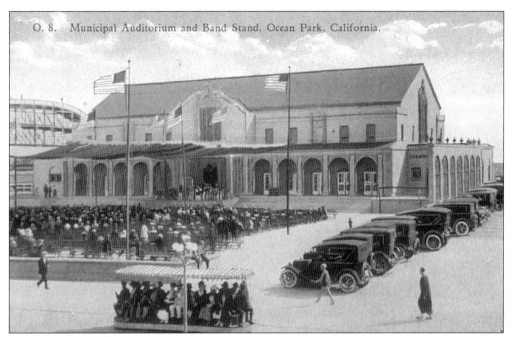

Municipal Auditorium and Band Stand, Ocean Park, California. (Western Publishing & Novelty Co., Los Angeles. No. O.8.)

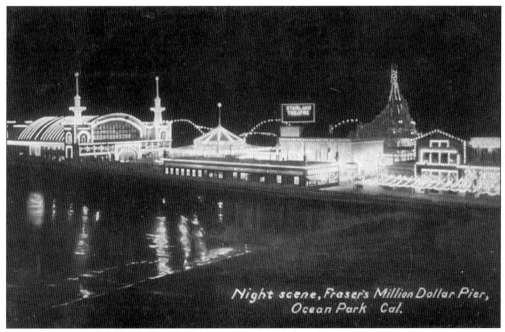

Night Scene, Fraser's Million Dollar Pier, Ocean Park, Cal. (The O. Newman Co., Los Angeles & San Francisco. No. F127.)

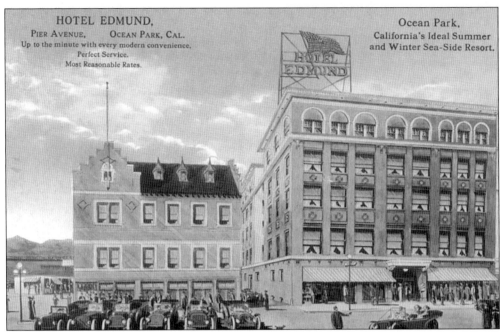

OCEAN PARK, CALIFORNIA'S IDEAL SUMMER AND WINTER SEA-SIDE RESORT. Hotel Edmund, Pier Avenue, Ocean Park, Cal. (Curt Teich Co., Chicago. No. R41890.)

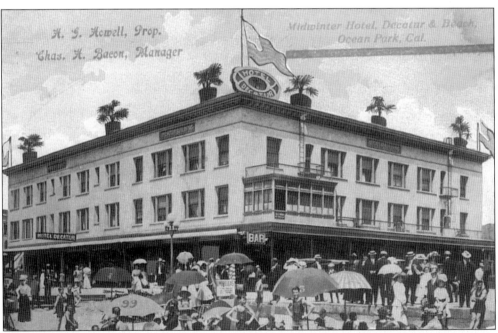

MIDWINTER HOTEL, DECATUR & BEACH, OCEAN PARK, CAL. 'H.G. Howell, Prop. Chas. H. Bacon, Manager. Hotel Decatur. Hotel located on the ocean front, 100 feet from the water edge of the beautiful Santa Monica Bay, the finest beach on the Pacific Coast where bathing may be enjoyed 365 days in the year.' (Unknown. 8814. Postmark: May 25, 1912.)

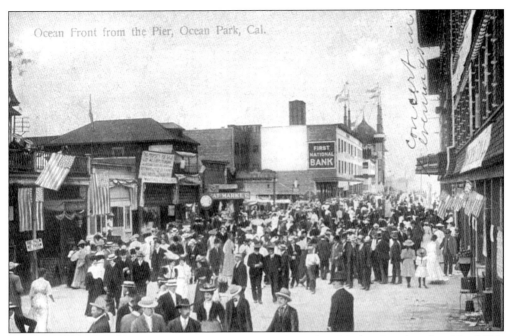

OCEAN FRONT FROM THE PIER, OCEAN PARK, CAL. (M. Rieder, Los Angeles. No. 2836. Made in Germany. Postmark: June 1907.)

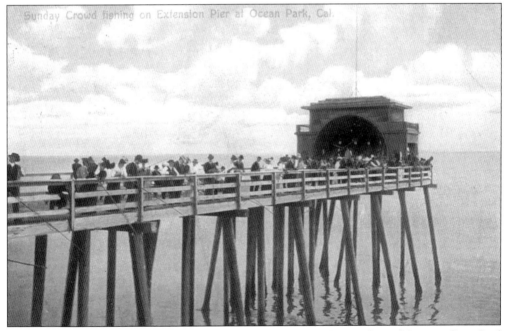

SUNDAY CROWD FISHING ON EXTENSION PIER AT OCEAN PARK, CAL. (Newman Post Card Co., Los Angeles. No. 6194. Made in Germany. Postmark: November 1910.)

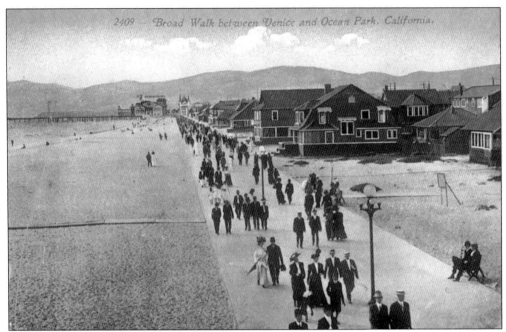

BROAD WALK BETWEEN VENICE AND OCEAN PARK, CALIFORNIA. (Edward H. Mitchell, San Francisco. No. 2409. Postmark: September 1912.)

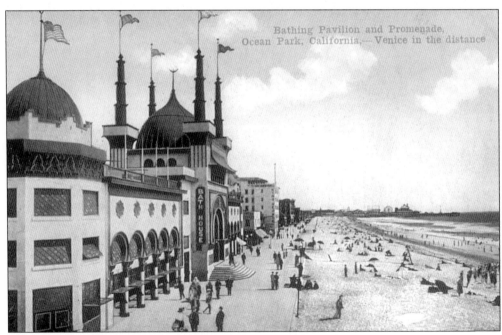

BATHING PAVILION AND PROMENADE, OCEAN PARK, CALIFORNIA, VENICE IN THE DISTANCE. (VanOrnum Colorprint Co., Los Angeles. No. 528.)

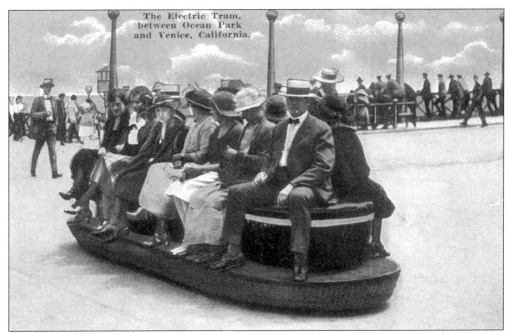

THE ELECTRIC TRAM, BETWEEN OCEAN PARK AND VENICE, CALIFORNIA. (California Postcard Co., Los Angeles. No. 25132N.)

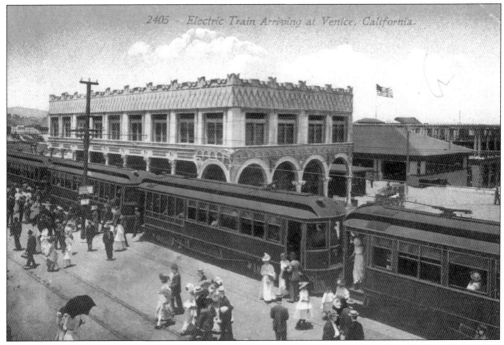

ELECTRIC TRAIN ARRIVING AT VENICE CALIFORNIA. (Edward H. Mitchell, San Francisco. No. 2405. Postmark: December 1918.)

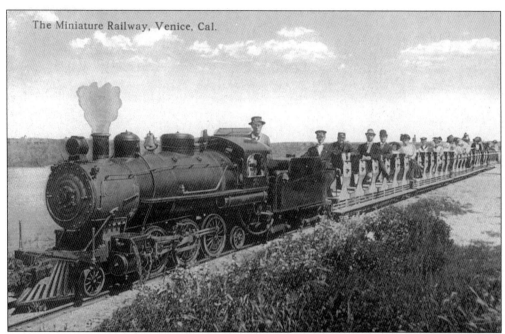

THE MINIATURE RAILWAY, VENICE, CAL. (Western Publishing & Novelty Co., Los Angeles. No. A.1251.)

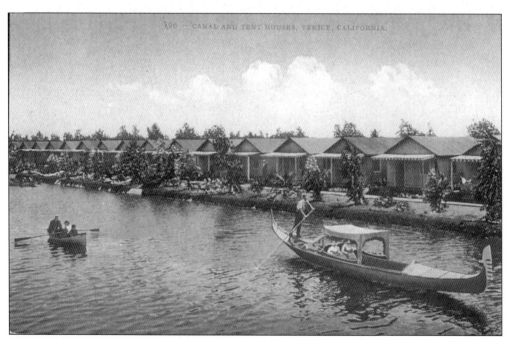

CANAL AND TENT HOUSES, VENICE, CALIFORNIA. (Edward H. Mitchell, San Francisco. No. 796.)

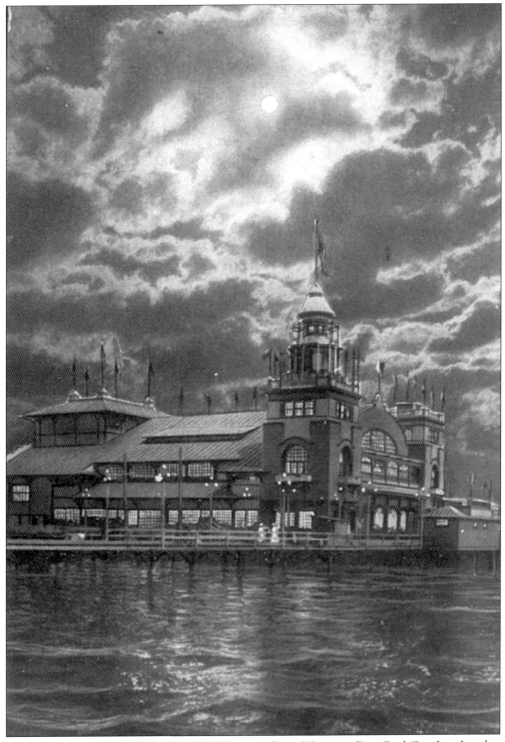

VENETIAN GARDENS BY MOONLIGHT, VENICE, CAL. (Newman Post Card Co., Los Angeles. No. 6072. Made in Germany.)

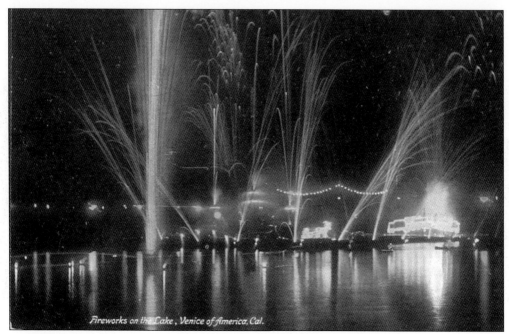

FIREWORKS ON THE LAKE, VENICE OF AMERICA, CAL. (M. Rieder, Los Angeles. No. 4894. Made in Germany.)

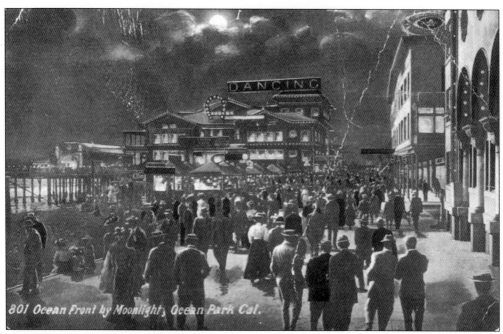

OCEAN FRONT BY MOONLIGHT, OCEAN PARK, CAL. (Edward H. Mitchell, Los Angeles. No. 801. Postmark: April 12, 1912.)

A Sea Gull Convention at Santa Monica, Calif. (H.F. Rile, Santa Monica, Calif.)

Index of Publishers and Photographers

Bay News Co. 37, 38, 49, 58
Benham 19
Cardinelli-Vincent 22
Colorpicture 68
California Greeting Card Co. 34, 49, 59, 75
California Post Card Co. 29, 36, 59, 82, 123
Detroit Photographic 11, 39, 62, 116, 117
Dillingham 101, 103
Georgian Hotel 74
Gird, E.C. 95, 96, 98
Illustrated Postal Card Co. 52
Kashower, M. 9, 20, 23, 24, 25, 32, 33, 35, 42, 48, 70, 77, 82, 85, 86, 110, 112, 113
Koeber, Paul 2, 14, 46, 55, 58
Kropp, E.C. 64, 72, 73
Libman, M.B. 70, 71, 81
Longshaw Card Co. 17, 26, 27, 28, 32, 76, 77, 84
Merchants National Bank 57
Mitchell, Edward H. 10, 27, 54, 55, 61, 62, 80, 85, 93, 109, 111, 122, 123, 124, 126
Newman Post Card Co. 6, 12, 15, 16, 41, 45, 50, 56, 63, 93, 106, 107, 108, 109, 118, 119, 121, 125
Newsstand Distributors 17, 89
Pacific Novelty Co. 16, 22, 24, 40, 60, 78, 81, 89, 111
Plunkett, Bob 102
Post Fund, Soldiers' Home 95, 96, 97, 98
Reeves, Walter 39, 52, 78
Rieder, M. 29, 30, 45, 46, 47, 51, 53, 61, 63, 84, 106, 108, 113, 115, 116, 121, 126
Restall, George 12, 94
Rice & Sons, Geo. 57, 64, 65, 66, 67, 73
Rile, H.F. 40, 127
Rogers Photo 99
Santa Monica Chamber of Commerce 79, 114
Sheward 48
Souvenir Publishing Co. 79, 107
I. Stern 105
Curt Teich 69, 72, 120
Tichnor 38, 87, 88, 97, 114
VanOrnum Colorprint 117, 122
Western Publishing & Novelty Co. 14, 25, 26, 31, 33, 35, 36, 37, 41, 42, 43, 44, 47, 60, 76, 83, 87, 99, 110, 112, 119, 124
Woods Post Cards 56, 65
Unknown 11, 13, 18, 19, 21, 75, 90, 91, 92, 94, 100, 104, 120